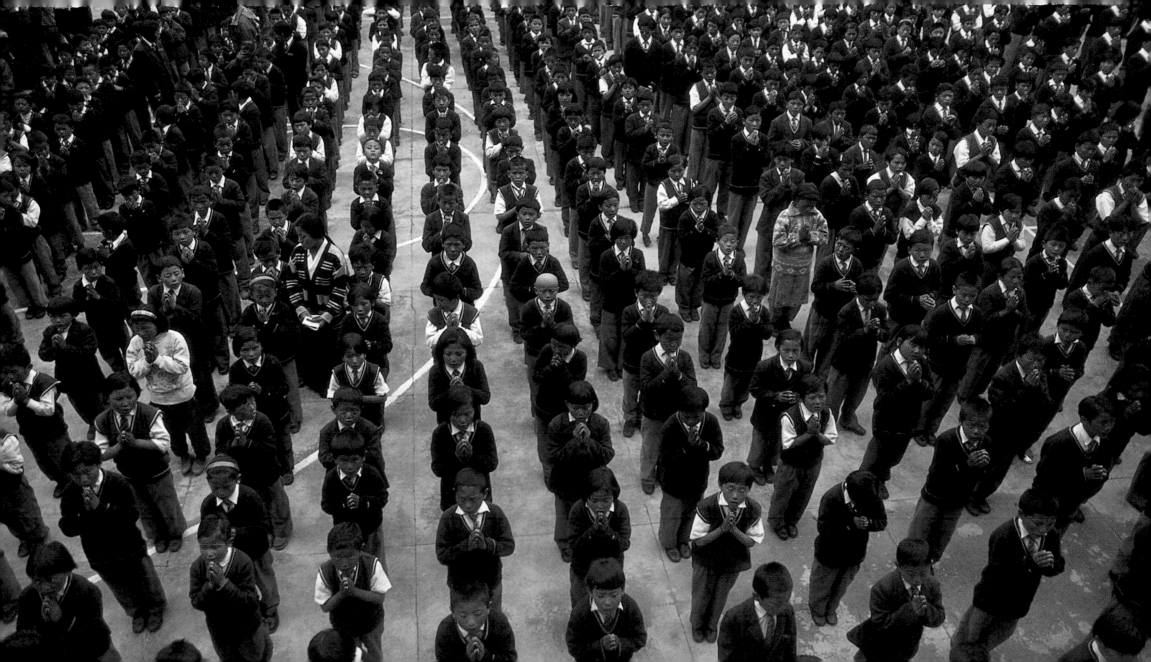

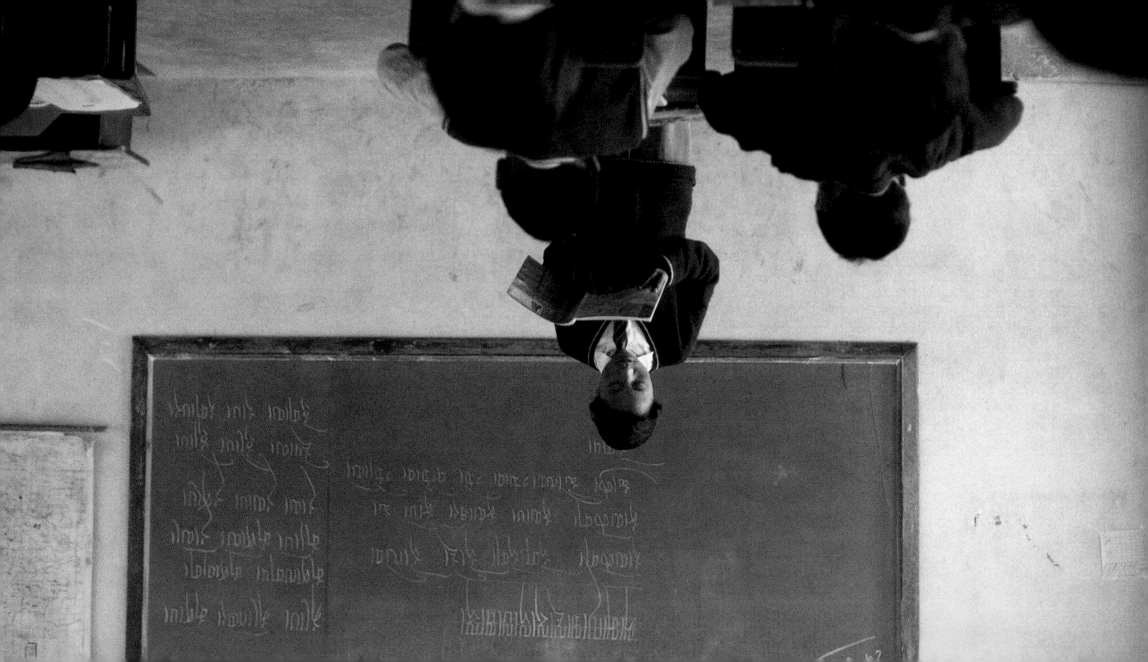

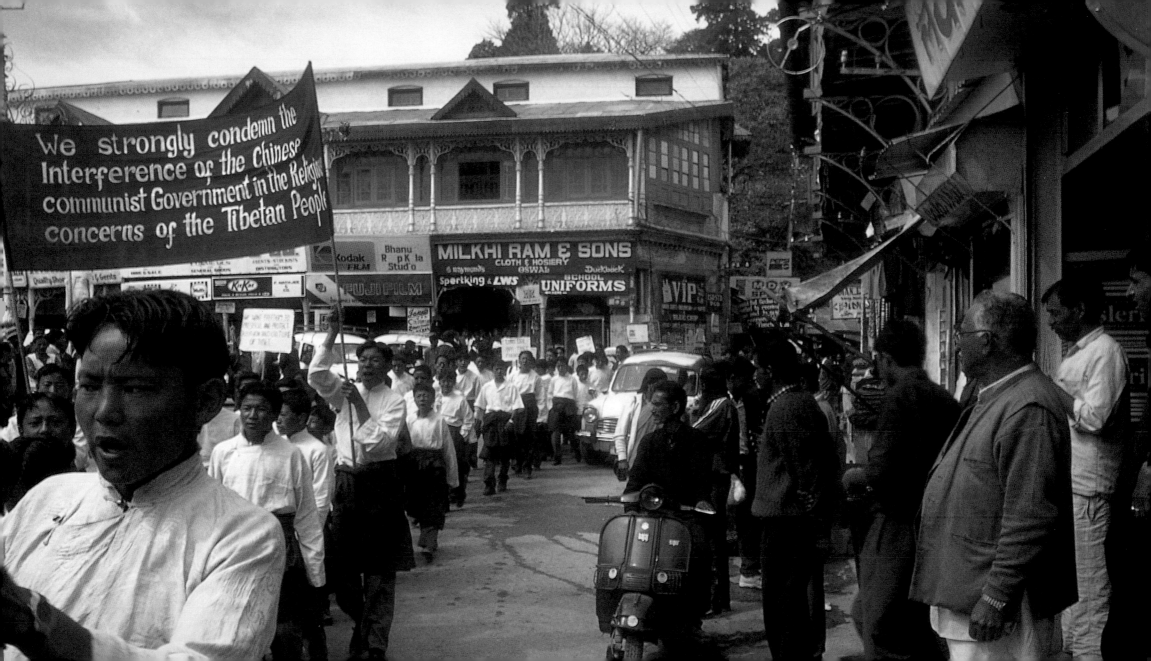

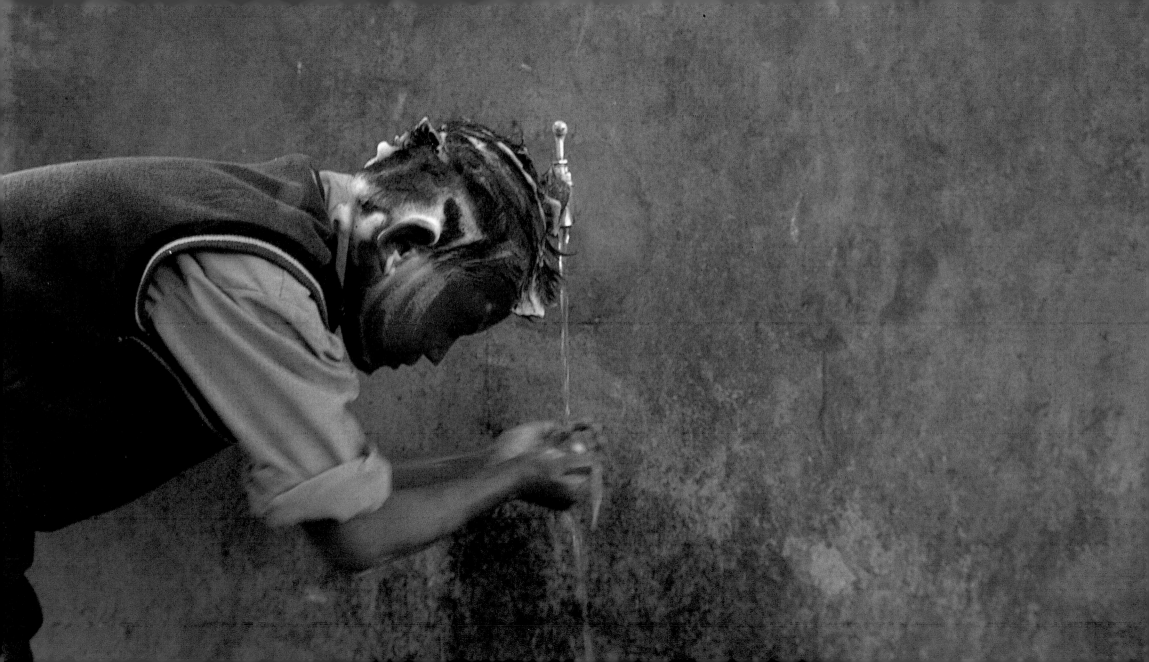

Conceived by the Museum of International Folk Art

Painting Clubs founded and sponsored by Sarah K. Lukas
and Friends of Tibetan Women's Association

Photographs by Kitty Leaken Foreword by Frank J. Korom
With an essay by Clare Harris

The Art of Exile

PAINTINGS

BY

TIBETAN

CHILDREN

IN

INDIA

MUSEUM OF NEW MEXICO PRESS
SANTA FE

Interviews conducted at Tibetan Homes Foundation, Mussoorie, India, in 1997 by Sarah K. Lukas, Kitty Leaken, and Thinley Gyaltsen. Plate captions compiled by Frank J. Korom.

Paintings made by students of Tibetan Homes Foundation between 1994 and 1997 in painting clubs conducted by Sarah Lukas.

Published to coincide with an exhibit at the Museum of International Folk Art in Santa Fe entitled "At Home Away from Home: Tibetan Culture in Exile."

Project editor: Mary Wachs
Design and Production: David Skolkin

Manufactured in Singapore
10 9 8 7 6 5 4 3 2 1

MUSEUM OF NEW MEXICO PRESS
Post Office box 2087
Santa Fe, New Mexico 87504

FRIENDS OF TIBETAN WOMEN'S ASSOCIATION
Post Office Box 22701
Santa Barbara, California 93121
805-962-1190
fotwa@rain.org
www.rain.org/~fotwa

Library of Congress Cataloging-in-Publication Data
The art of exile : paintings by Tibetan children in India / conceived
 by Sarah K. Lukas and friends of Tibetan Women's Association, U.S.A. :
 photographs by Kitty Leaken : with an essay by Clare Harris.
 p. cm.
 ISBN 0-89013-352-2 (jkt'd pbk.) . — ISBN 0-89013-356-5 (pbk. in
slipcase)
 1. Children's art—India. 2. Child artists—India—Psychology.
3. Tibet (China)—In art. I. Lukas, Sarah. K. II. Leaken, Kitty,
1958- . III. Harris, Clare.
 N352.2.I4A78 1998
 704' . 054—dc21 97-41828
 CIP

A NOTE ON BIOGRAPHICAL MATERIAL:
Names, ages, and places of birth for the children at Tibetan Homes Foundation may be incomplete or inconsistent as a consequence of the conditions under which Tibetan refugees arrived and live in India.

Contents

Yak Herder

BY JAMPA GYALTSEN
BORN IN NEPAL IN 1978.
CAME TO TIBETAN HOMES AT
EIGHT MONTHS.

T h a n k Y o u

By Sarah K. Lukas and Kitty Leaken

A VERY SPECIAL THANK YOU and *Tashi Delek* to all the children at Tibetan Homes Foundation (THF) and especially to those who came up to paint. To Pema Dechen Gorap, former General Secretary at THF, who has blessed and nourished this project from the beginning, much love and gratitude. Thinley Gyaltsen has been our invaluable collaborator, translator, and friend. Headmasters Ngodup Sangmo and Ngodup Norbu opened classroom doors and gave permission for time to paint. Teachers Chime Wangmo and Deckyi Lhaze in Rajpur opened their home and hearts with true Tibetan hospitality. Teachers Yeshi and Passang helped out when we were overloaded with seventy-two children in the first painting club. Tsering Bhakdo's extensive cultural, religious, and historical knowledge provided much insight. Tsering Paldon and other THF administrators have helped over the years with a myriad of details. At the Vocational Training Centre, administrator Dorje Taksar and *thangka* painting teacher Dornam allocated much time for students to paint. In Dharamsala, the Amnye Machen Institute provided valuable computer time.

Mary Wachs and David Skolkin at the Museum of New Mexico Press have brought a beautiful vision to this project. Katharine Kagel and Stephen Harrison offered warm and delightful support. And Jim, Kathryn, and Richard Leaken have been the best family that one could ever wish for.

To Sonam Chophel, oil painting teacher and dear friend, our deepest gratitude. Sonam helped us navigate the paths of another culture and had the vision and humor to keep us going when our spirits sagged. He also kept us well plied with tea.

Foreword

By Frank J. Korom, Curator of Asian and Middle Eastern Collections, Museum of International Folk Art

SINCE 1959, THE YEAR THAT HIS HOLINESS THE FOURTEENTH DALAI LAMA escaped to India, it has been estimated that at least 131,000 Tibetans[1] have fled their homeland to seek shelter in other parts of the world. This unprecedented mass migration out of Tibet is due to ongoing conflict between Tibet and the People's Republic of China (PRC) over questions of political autonomy and cultural self-determination. While not denying that Tibet has interacted historically with the PRC in cultural and economic terms over a period of many centuries, the government-in-exile still maintains that the Tibetan Autonomous Region, as the country is now officially called, was indeed a sovereign nation before the Chinese occupation. Opinions about this controversy are heated on both sides, making dialogue difficult. As a result, an official resolution still seems a mere distant hope despite the constant media attention the dispute attracts. Whatever position one takes on the "Tibet issue," the reality of the situation remains: Many Tibetans, be they in India, Nepal, Europe, or North America, now live in a perpetual atmosphere of displacement.

One of the great tragedies arising out of the above scenario is the impact that exile has had on children. Many who were born in Tibet, and whose voices are heard in this book, tell of harrowing experiences crossing the Himalayas on foot, on horseback, or by truck to seek refuge in South Asia, perhaps never to see their families and friends again. Other Tibetan children who were born in India or Nepal grow up learning about their cultural traditions through the stories and guidance of adult refugees

or in the classroom. To them, Tibet is a real, albeit imagined, place that must be conjured up and preserved in any way possible. The issue of preservation, we should note, is a theme pervading discussions about Tibetan diasporic culture.

Many people, both Tibetans and their foreign sympathizers, fear that traditional Tibetan culture, with its distinct spiritual heritage, is rapidly disappearing. While this may be true to a significant extent, it is also important to acknowledge that Tibetans have evidenced a remarkable resilience, thereby allowing them to develop further their language, religion, and culture even while adapting to their new environments over a period of more than thirty-five years in exile. The Tibetans' ongoing success in perpetuating their own culture in exile thus far stems from the fact that they were able partially to reconstruct their ways of life with financial assistance from a number of foreign sources, as well as through collaboration with various agencies in their host countries.

The perpetuation of Tibetan traditions abroad will depend on the degree to which elders will be able to continue to transmit their personal knowledge to future generations of Tibetans born in exile. The resolve of children as bearers of culture will thus determine whether or not the image of Tibet will remain vivid well into the next century. Needless to say, their education and care are primary concerns. Schools have served the purpose of educating the many Tibetan children who have been separated from their families as a result of their flight or who are learning about Tibet for the first time in an alien milieu. Educational institutions, be they monastic or secular, have been a great factor in the revitalization of Tibetan culture in exile, and it is from one such school, the Tibetan Homes Foundation (THF) in Mussoorie, a mountainous hill station in north India, that the paintings reproduced in this book originate.

Established in 1962, the school provides for the physical and intellectual needs of disadvantaged Tibetan children in South Asia. Today, more than 1,700 children are cared for by THF. Some have gone on to work for the Tibetan government-in-exile, while others have entered professions utilizing artistic skills such as painting. *Thangka* painting is one of the best-known forms of Tibetan Buddhist art, and some children enroll in *thangka* painting classes as an integral part of the curriculum. However, lesser

known is the fact that students are now also learning to express themselves in a different, secular style when they participate in the painting club discussed by Kitty Leaken in the text that follows. Such paintings allow these children to express their feelings of displacement visually by transferring their lived experiences onto canvases. This is, for many, a form of therapy to help cope with their sense of confusion and loss. A social psychologist who conducts research on adolescent art has recently written that "To produce art is not only to illustrate life, experiences and thoughts; by organizing and concretizing experiences and thus making them more comprehensible to oneself, art is also a means to construct identity. Making art, and the sensitive processing of everyday life that it enables, can help an artist to gain a sense of reflexive control over her life circumstances."[2] Indeed, the paintings included herein evince a distinct sense of the trauma of cultural rupture, of physical displacement, and display a strong sense of Tibetanness by drawing on the profound experiences of leaving home to adjust to life in India. Moreover, many also allow the painters alternatively to remember or imagine home. In the interpretive essay that follows the paintings, art historian Clare Harris, who herself taught at THF in the 1980s, provides us with some ways to understand the stories these paintings tell.

When the Museum of International Folk Art embarked on the planning of an exhibition on Tibetan culture in exile, I went to Dharamsala to explore the possibilities. On my second trip there in 1996, I met Sarah Lukas, president of the Friends of Tibetan Women's Association (FOTWA). She shared her collection of children's paintings with me. As I examined the paintings, I was struck with their power to convey feelings difficult to describe in words. It was then that I decided to present some of the paintings at the museum for inclusion in our exhibition. Photographer Kitty Leaken, whose own impressions follow, had already been working closely with Lukas to document the children of THF. When we all met during the summer of 1996 in Santa Fe, we collectively deemed it wise to supplement the paintings with oral narratives to be provided by the painters themselves. Kitty Leaken, Sarah Lukas, and Thinley Gyaltsen have dedicated a commendable amount of energy to documenting the children's artistic progress and to recording and transcribing their stories, which figure prominently in the captions for the paintings. Taken

together, the paintings and narratives suggest the strength and creativity of these children who have lost so much but who now stand to gain. At the same time, their art and stories also should remind us of the harsh sociological realities of refugee life.

This book reflects much of the thinking that went into the planning of the exhibit "At Home Away from Home: Tibetan Culture in Exile" and mirrors the collaborative spirit that goes into any successful museum project. Museum director Charlene Cerny originated the idea for an exhibition on Tibet, and educator Laura Temple Sullivan also played a key role.

Many agencies financially supported the development and implementation of the exhibition that inspired this publiscation, specifically the National Endowment for the Humanities, a federal agency; the International Folk Art Foundation; the Museum of New Mexico Foundation; the Fund for Folk Culture's Conferences and Gatherings Program, underwritten by the Pew Charitable Trusts; the McCune Foundation; the City of Santa Fe Children and Youth Fund; and the Friends of Folk Art.

1. This number is based on the figure provided by the Central Tibetan Administration of the government-in-exile, which is located in Dharamsala, India. See Frank J. Korom, "Tibetans," in David Levinson, ed., *American Immigrant Cultures: Builders of a Nation* (New York: Macmillan, 1997), 888–96.
2. Rantala, Kati. "Narrative Identity and Artistic Narration: The Story of Adolescents' Art." *Journal of Material Culture* 2 (1997): 219–40.

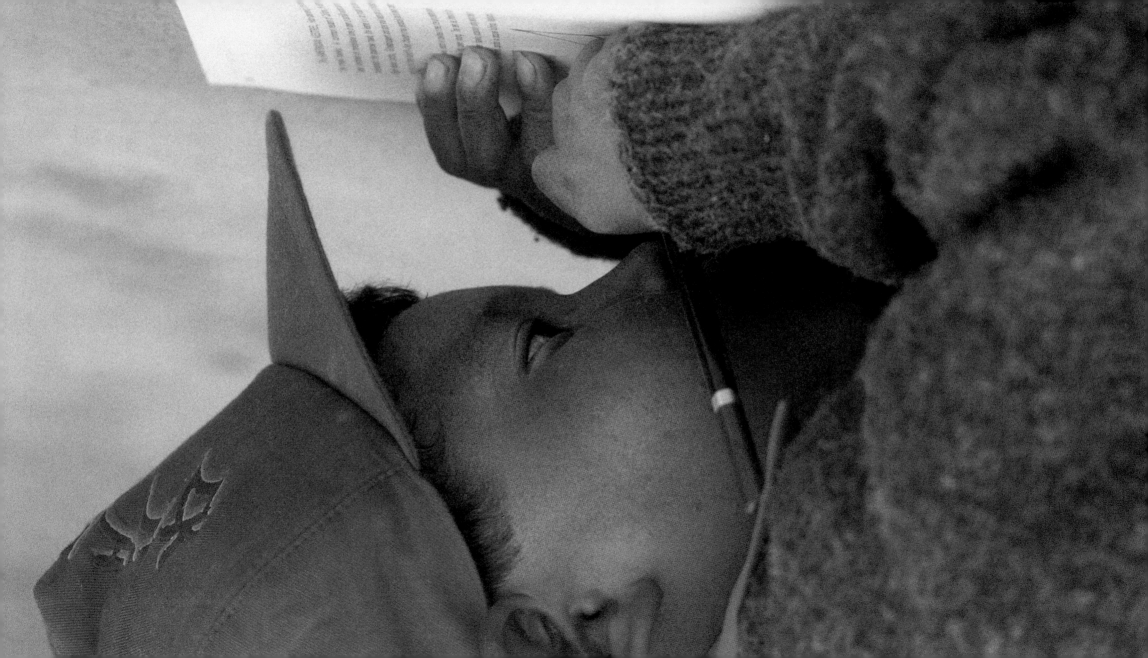

A Way Home

By Kitty Leaken

TSERING CHOPHEL

WITH THE SNOWY HIMALAYAN PEAKS OF TIBET BEHIND HIM, nine-year-old Tsering Chophel stepped off the bus in Dharamsala, India, in March 1994. He limped slightly as he made his way down to the reception center of the Tibetan government-in-exile. Officials there offered food and bedding and would soon enroll him in a Tibetan school in India, but they could offer no assurance that he would return home or ever see his family again.

Every month Tibetans arrive at the reception center, compelled to leave repressive conditions at home imposed by Chinese communist authorities. Since 1959, more than one hundred thirty thousand Tibetans have followed their leader, His Holiness the Dalai Lama, into exile in India.

above
TSERING CHOPHEL, THE INSPIRATION FOR THE PAINTING CLUB.

We met Tsering the day after he arrived in India. He was frightened and unsure and far too serious for his nine years. Francisca van Holthoon, a Dutch woman fluent in Tibetan who was gathering information for an international organization, joined us on the rooftop of the reception center to interview Tsering. Sarah Lukas, an American active in aiding Tibetans in exile, had brought watercolors and a coloring book. I had a purple hat just purchased at a handicraft center. It said *Rangzen* (freedom), and it was obvious that the young boy coveted it.

Tsering's voice was very quiet when he began his story.

His father was killed in a demonstration in Lhasa. His mother was a street sweeper. During school vacations, he hung out with his mother's sister in her shop in Lhasa. It seems he was close to his "aunty," and it was she who arranged for his trip to India. They had heard that there were schools in India where he could get a good Tibetan education. His mother filled two small backpacks with warm clothes and, saying a prayer for his safe journey, sent Tsering off to be entrusted to a Tibetan family that was headed for Nepal.

Passed along from the care of one Tibetan family to the next, Tsering remembers long bus rides through the night until the dangerous journey on foot

began. Hiking by night and sleeping by day in order to evade Chinese border patrols, they crossed several fifteen thousand–foot mountain passes. He injured his leg in a fall but did not complain about the bitter cold, blinding high-altitude sun, or lack of food during the journey.

Tsering couldn't say how long the trip had taken; he didn't know. When he arrived in Nepal, he was gently embraced by the long arms of the Tibetan community in exile. In Kathmandu he was put on a bus for Dharamsala.

At this point in the interview Tsering picked up the paintbrush Sarah had offered earlier. He dabbed it into a film canister of water and opened up the coloring book. Under the brow of his new purple *Rangzen* hat, Tsering became absorbed in painting. It was time to play.

Several weeks later Sarah and I found ourselves many kilometers away at Tibetan Homes Foundation (THF) in Mussoorie, India. In the morning assembly we looked for our young friend across regimented rows of more than a thousand uniformed schoolchildren. We found him with a radiant smile under his purple hat. Tsering hadn't yet received his uniform, but he'd found his new home.

TIBETAN HOMES FOUNDATION

In the cold mornings, a mist rises from the foothills of the Himalayas. Beyond the steep hillsides on which Tibetan Homes Foundation is perched, gloriously snowcapped mountain peaks catch the first rays of sunlight. The school day begins around

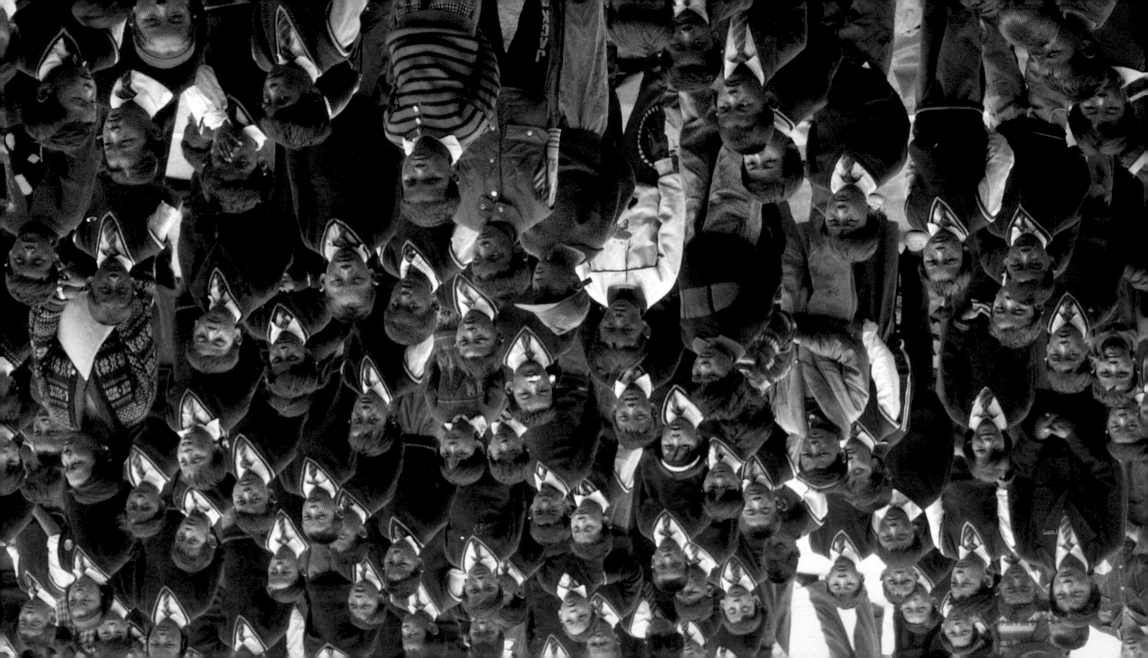

5:30 A.M. with the clanging of the gong. Children climb out of crowded bunk beds and dormitories into their green-and-gray uniforms. They brush their teeth and then drink tea. Almost an hour of prayer and chanting fills the hills around the school. Sunlight has reached the valleys by the time they clatter down to morning assembly.

THF was established in 1962 under the direction of His Holiness the Dalai Lama. It was formed as an emergency measure to receive the waves of refugee children arriving from Tibet. Mary (Rinchen Dolma) Taring and her husband Jigme Taring, from an aristocratic family in Lhasa, were entrusted with the responsibility of starting the school.

In her book *Daughter of Tibet*, Mrs. Taring tells of the extraordinary difficulties of such a task. With very little funding from private sources, the Tarings oversaw the building of homes and classrooms, hired teachers, and sought food and medical help for children who had a hard time adjusting to India's climate. Of utmost importance in their education was the need to preserve the Tibetan language and culture.

THF is a full-fledged senior secondary school, kindergarten through class twelve, with a branch school in Rajpur, an hour away. (Tibetan Children's Village is a similar school in Dharamsala.) Students are instructed in Tibetan, English, and Hindi and compete in the all-India school board examinations. In

above
WE FOUND TSERING AT TIBETAN HOMES AMONG THE NEW ARRIVALS (WITHOUT UNIFORMS).

MRS. TARING LIVES AN HOUR FROM THE SCHOOL SHE HELPED FOUND TO RECEIVE THE WAVES OF CHILDREN LEAVING TIBET.

TSERING MAKES HIS FIRST FORAY INTO THE INDIAN TOURIST HILL STATION
OF MUSSOORIE.

1997 THF had 1,514 children enrolled, with 144 in Rajpur; 915 students are from Tibet, with the rest from Tibetan settlements around India. Between January and June of 1997, fifty-two new arrivals came from Tibet. THF serves as a year-round boarding school for more than seven hundred children who cannot return to Tibet and who have no place to go.

Scattered across the hillsides are thirty large homes with forty to fifty children in each and eleven smaller homes with twelve children each. There are two foster parents in the larger homes and a housemother who looks after the children in the smaller homes. She is occasionally helped by an aunty. There are two youth hostels for the senior boys and girls. Children receive meals in their homes, and a house captain makes sure they study in the evenings, checks that their uniforms are neat, and oversees prayer two times a day.

There is a Buddhist temple, and several monks teach religion classes in the school. The Vocational Training Centre (VTC) provides training in tailoring, weaving, and knitting, as well as in oil painting and traditional Tibetan *thangka* painting. A small dis-

pensary and dental clinic tend to basic medical needs; more serious patients are referred to hospitals in Mussoorie. THF also administers two Old Peoples' Homes with some four hundred elderly and infirm who have no family to support them.

To this day, the United Nations does not politically recognize the Tibetan government-in-exile or Tibet's claim to independence. China's enormous economic clout forces the world to overlook its continuing abuse of human rights in Tibet. Unlike many refugee communities, there are no official channels for international assistance to Tibet or to Tibetans in exile.

THF has no reliable source of income. It is completely dependent on the donations of philanthropic individuals and organizations. Individuals can sponsor a child for $30 a month, which helps the school provide uniforms, food, and a little pocket money. Save the Children Fund, THF's major source, recently has indicated that it will soon be cutting its long-standing support. There is grave concern over where funding will come from next.

THE PAINTING CLUB

Sarah Lukas couldn't forget Tsering Chophel's reaction to paint and brush at the reception center in Dharamsala; the seeds were sown. She realized that play and creativity could bring relief to young children exposed too early to such trauma. Sarah's organization, Friends of Tibetan Women's Association (FOTWA), was dedicated to improving the quality of life for Tibetans in exile, especially children. FOTWA would provide art supplies. With the blessing of Pema Dechen Gorap, General Secretary of THF at the time, the painting club began in 1995.

Untitled

BY CHOMPEL

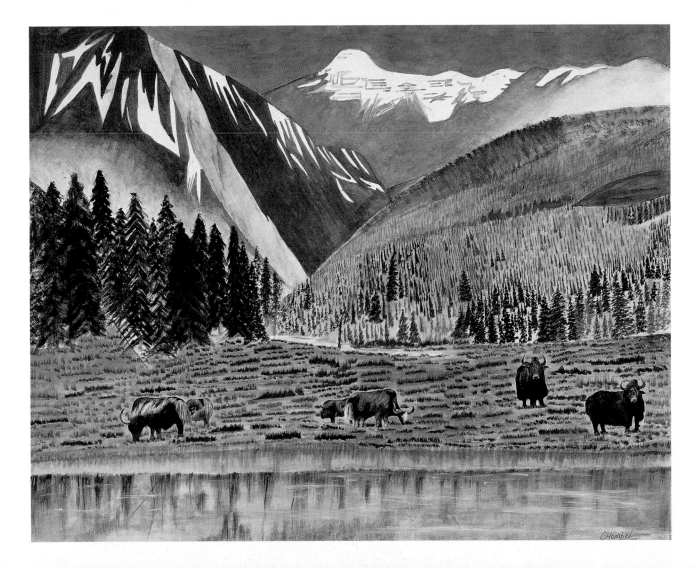

In all, seventy-two children from the ages of eight to eighteen met every day after class, seven days a week, to enthusiastically apply tempera—and feelings—to paper. Most had never held a paintbrush before and didn't know how to begin. At the beginning, the children had to be encouraged to take risks and delve into their imaginations, but by the end of the fourth painting club, three years later, we noticed that they had grown as artists in their technical abilities, in their self-expression, and in their excitement for their work.

TSERING, 1994 AND 1996.

In the spring of 1996 another month-long painting club was held. In brainstorming sessions the children made lists of what they would paint, such as *Losar* (Tibetan New Year) or life in Tibet as they remembered it.

Every day after school, Sonam Chophel, the oil painting teacher at the Vocational Training Centre at THF, opened the doors of his classroom to us and the paper and poster color were brought out. Tea was served. Some boys would come downstairs from *thangka* painting class, where they were training in traditional Tibetan art. The techniques they were learning of shading for mountains and sky in a rigorous study of Buddhist iconography were apparent in the paintings they made freely in the club.

Sarah and I stayed at the Hotel Carleton just outside the school. Once an English country home, the rooms were cold, inexpensive, and decorated with stuffed animals, hunting trophies from the more prosperous days of the British raj. While Sarah tended to the painting club in Sonam Chophel's classroom, Thinley Gyaltsen and I headed out to interview students. In his late twenties, Thinley had been a student at THF and still had friends there. As collaborator and translator, Thinley asked important questions and patiently helped the children open up with their stories.

RANGZEN

On our second visit to Mussoorie, we found Tsering having his temperature taken in the dispensary. He'd knocked out a few teeth in a fall but soon was playing cards with friends in the dispensary dormitory. In 1997, a year later and now thirteen years old, Tsering had graduated to Class 4. This time I found him playing *carrom* board with his housemates, a popular board game in India. Tsering demonstrated the same concentration and camaraderie that I saw later in class. His housemother had commented

top, from left:
TSERING AND
FELLOW NEW
ARRIVAL; A YEAR
LATER AT THE
DISPENSARY.

bottom, from left:
RUNNING A LOW
FEVER, TSERING IS
ALLOWED A DAY
OFF FROM CLASS
TO PLAY CARDS IN
THE DISPENSARY
DORMITORY;
TSERING IN 1997.

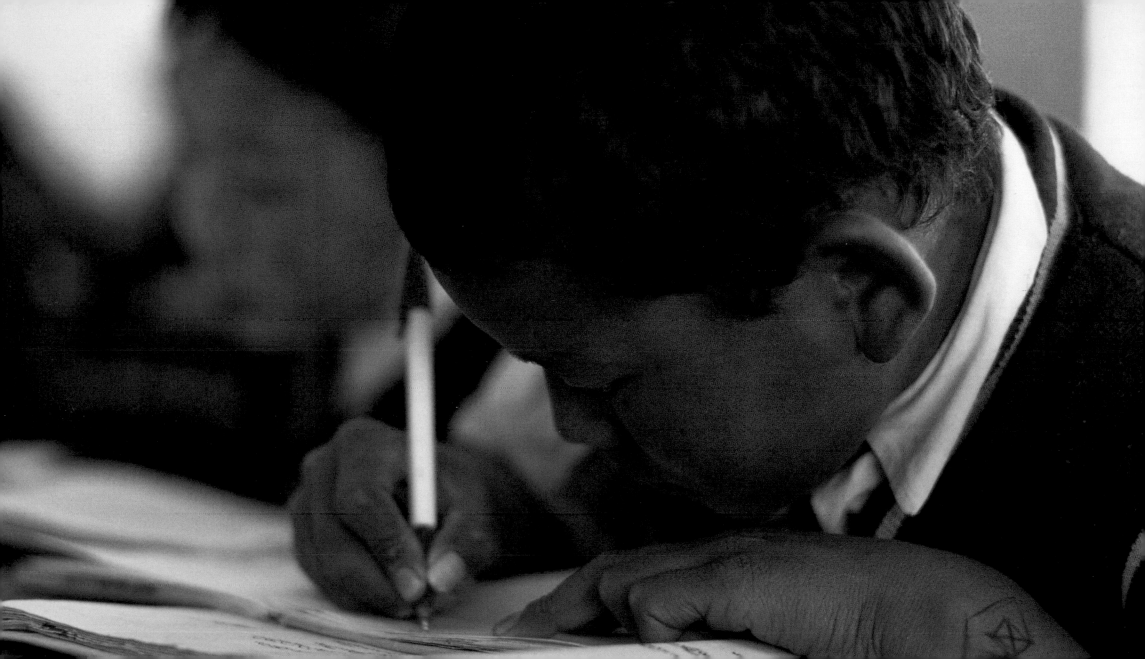

that Tsering looked out for the younger children in his home and made sure their uniforms would pass inspection in morning assembly. Tsering still didn't speak English, and my attempts at Tibetan only brought forth gales of laughter. So we just smiled at each other. I slipped him a little pocket money and asked Thinley to convey the instructions that not all be spent on candy. A tidy Indian-run shop around the corner was always crowded with children counting out rupees for candy, cookies, pencils, or toilet paper.

Less than two hundred miles northwest of Delhi, Mussoorie is an Indian tourist destination, a hill station built by the British to escape the heat of the plains. It has a kind of faded carnival atmosphere, with a cable car, pony rides, and a foot-peddled Ferris wheel. Old British mansions have been converted to hotels near several of India's best boarding schools, and the street along the mall has been closed to trucks and automobiles. In full strength THF residents enter Mussoorie once a year on March 10. It marks the anniversary of a bold uprising against the Chinese invaders in Lhasa. In a parade with banners and loudspeakers, students and teachers march around the mall shouting with all their might for freedom—*Rangzen!*

His purple *Rangzen* hat long gone, Tsering has made his home here. In India he has the freedom to study Tibetan, to play and to create. He now has the freedoms of childhood, as best as can be provided for children who have left their homeland.

Rangzen!

above
TSERING IN THE PAINTING CLUB.

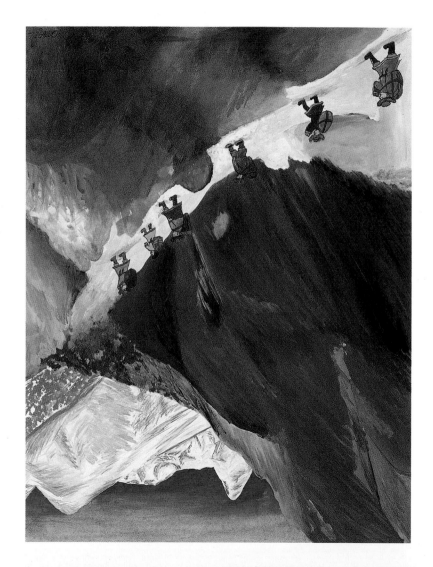

PAINTINGS

BY

TIBETAN

CHILDREN

IN

INDIA

L e a v i n g T i b e t

GYALWANG
Born in Tibet in 1979. Came to Tibetan Homes at age twelve.

I tell this story for my country but I want to request that you change all names and all dates.
My parents have been very kind to me so I don't want them to suffer.

above
THE ROAD OUT OF TIBET.

NEW ARRIVALS FROM
TIBET AWAIT THE BLESS-
INGS OF HIS HOLINESS
THE DALAI LAMA AS HE
LEAVES HIS RESIDENCE
IN DHARAMSALA, INDIA.

H. H. Leaving Tibet on a Yak

BY NGAWANG YOUDEN BORN IN TIBET. CAME TO TIBETAN HOMES IN 1991.

"In 1959 the Chinese tortured the Tibetans and His Holiness had to escape into India. This thought came into my mind so I painted it. The Chinese spied on His Holiness. They used to watch where we went when he escaped in the wintertime. He passed through the mountains, which were covered with snow. It was cold. In Tibet we are all tortured, but in India we are free to do anything. The rainbow symbolizes good luck with the arrival of His Holiness."

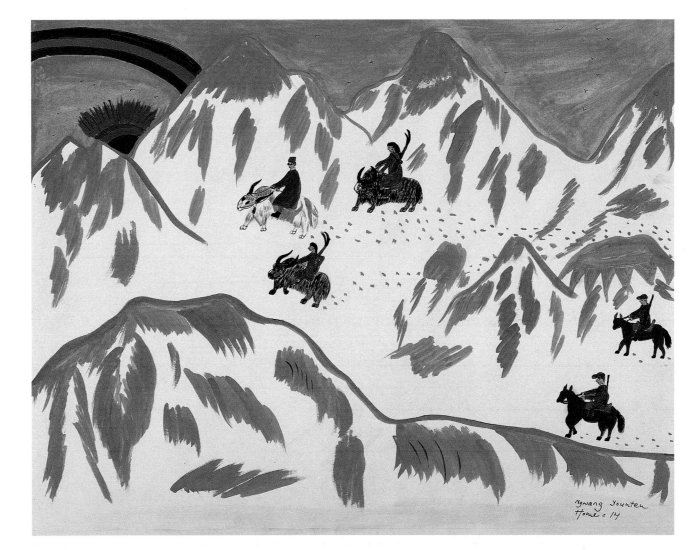

21

TSAMCHO DOLMA
Born in Tibet. Came to Tibetan Homes at about age thirteen.

We understand you have a very interesting story to tell us.

When I was coming to India I came from Lhasa to Shigatse by bus. From Shigatse, we went to Tingri again by bus. From Tingri to Sologompa we walked all the way. It took fifteen days walking day and night without sleeping at all. We walked continuously.

Were you alone?

I was with another boy from Lhasa. We were twenty-six people in all with one guardian.

Why didn't you sleep?

Because we were frightened the Chinese would catch us.

How old were you?

Twelve.

This was three years ago. You left your family back in Lhasa?

Yes.

Did they make the arrangements for you to leave?

My parents didn't do the arrangements, my older brother did it. I was sent actually to India on a pilgrimage.

You planned to go back?

Yes. When we reached Kathmandu, there were six of us. We all had frostbite badly. Some had to cut off their hands. I was admitted to a big hospital. I had terrible frostbite. I have lost my toes and most of my right foot.

Oh. That's why you couldn't sleep on the way out . . . it was bitter cold.

Yes, snow came up to here [her waist].

What were you thinking?

Just to have an audience with His Holiness and to go back to Tibet again.

Do you still want to go back to Lhasa?

Yes [crying].

Is it possible?

Now I feel quite sick and I will never find anyone who is going to Tibet. I have a fever and I can't see with my left eye.

I'm so sorry. Has it been possible to contact your parents?

I received one letter from my parents saying that my father is not well and to come back. He wasn't well when I left from Tibet.

And the other people that came with you?

The guardian carried the younger boy on his back. He was six years old. He is here in Home 24. The others were much older. I think some of them went to Bir school.

Were they in the hospital with you?

Yes, there were six of us in the hospital, including me. I was there for more than a year.

Just your foot?

Yes, my eye has become worse and worse here at school. We were given a kind of cloth to tie across our eyes because of so much reflection from the snow.

Snowblindness. What were you thinking on this journey?

I was thinking about going back home.

Was the weather bad? A lot of snow?

Yes, quite a lot of snow.

So, of course you couldn't sleep. You're freezing and you're hungry?

We had *tsampa* with butter and we survived on that up to Sologompa. There were so many passes that we went over.

Do you know other kids here who have had that hard a time coming out?

There is one in 5-D Class. I don't know his name. He faced a lot of problems.

It would maybe help you to talk to him and share your experiences. Tell me about being Tibetan.

[Silence]

What's the first thing you remember when I ask you about Tibet?

I only think about my parents.

TSAMCHO DOLMA.

Remembrance of My Friend

BY TSETAN CHOMPEL
BORN IN TIBET IN 1976.
CAME TO TIBETAN HOMES
AT AGE NINE.

"That's me, standing in the road. It is the time that I am leaving Tibet. I am on the right, in blue, and this is my friend. We are saying good-bye. I am offering him a *kathak* [auspicious white scarf]. We use them during Losar, on His Holiness's birthday, or on a special occasion like this when someone is leaving and saying good-bye."

above

THE OFFERING OF *KATHAKS* IS A TRADITIONAL TIBETAN GESTURE OF GREETING, FAREWELL, AND BLESSING. A TIBETAN BRIDE (CENTER) IS BESTOWED WITH *KATHAKS* FROM TEACHERS AT THE.

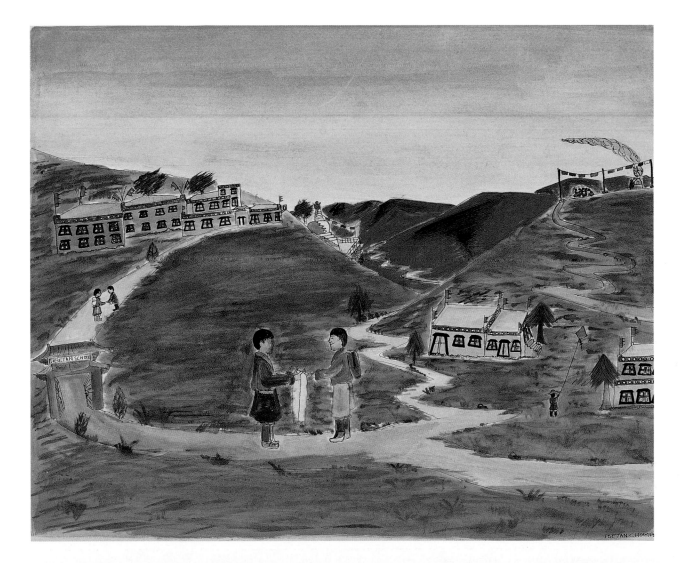

25

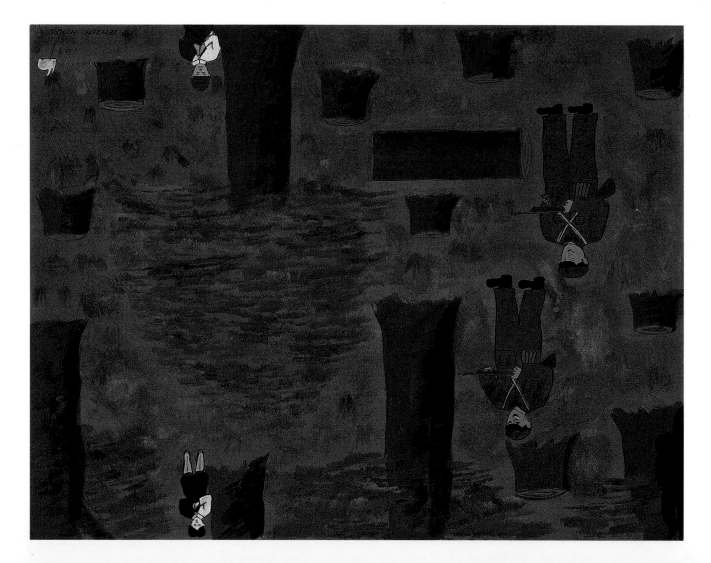

Hiding

BY TENZIN NORBU "A",
BORN IN TIBET IN 1981,
CAME TO TIBETAN HOMES
AT AGE ELEVEN.

"This is Jigme [artist's brother] and I on our way from Tibet. It is in the forest near Dam where we saw some Chinese cutting trees and taking the wood away in a truck. We were scared and thought they'd catch us so we hid behind some trees. We were very scared because we heard that if the Chinese caught us we would be put in jail along with all our family members."

Escaping from Tibet

BY THAKCHOE
BORN IN TIBET IN 1979.
CAME TO TIBETAN HOMES
AT AGE SEVEN.

"I don't remember much about
the trip. I remember some
small towns. From Tsurpu to
this bridge we came by truck.
After that we were walking.
The roads were very danger-
ous. They were caved in and
the rivers were across the
road."

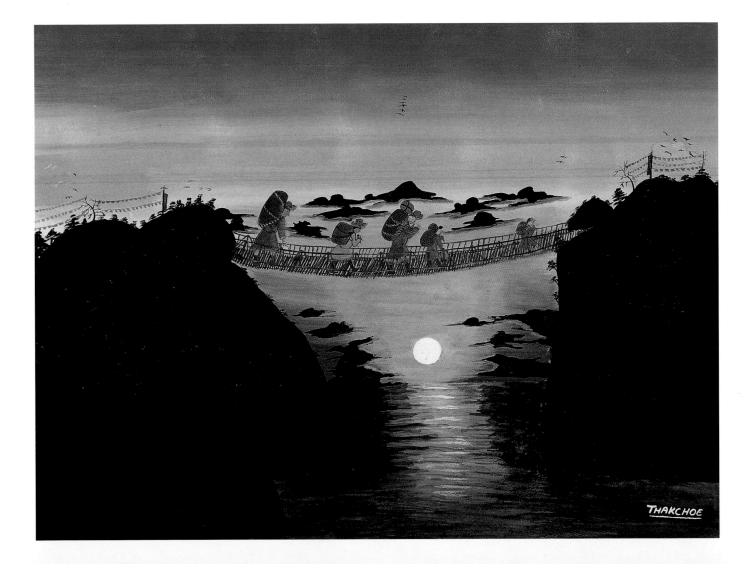

Offering Tea Along the Way

**BY THAKCHOE
BORN IN TIBET IN 1979.
CAME TO TIBETAN HOMES
AT AGE SEVEN.**

"We rested in the middle of the way and we had tea. Tibetan tea. We traveled during the daytime."

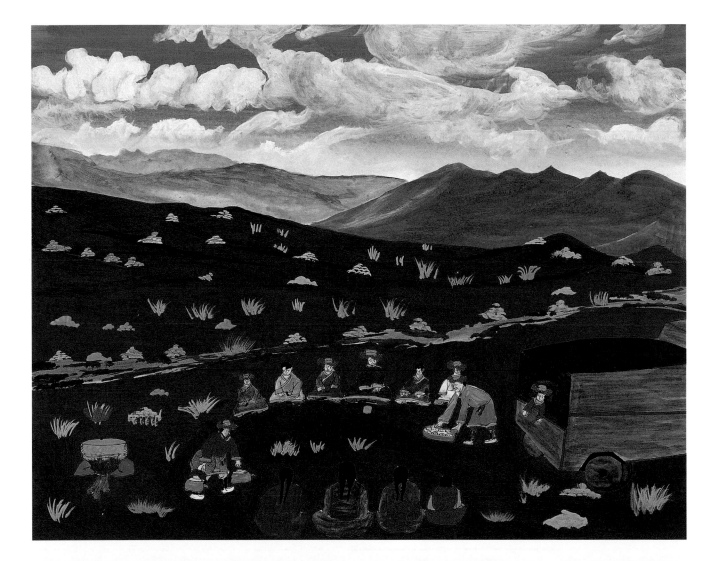

above

STOPPING FOR TEA IS A RITUAL REPEATED COUNTLESS TIMES A DAY IN TIBETAN FAMILIES. IT IS A TIME TO VISIT, TO REST, TO TALK, AND TO BE WITH FAMILY. THIS LADAKHI FAMILY COMES TOGETHER IN THE FIELDS DURING THE BARLEY HARVEST.

GYALWANG PAINTS
MY SORROW.

My Sorrow

BY GYALWANG
BORN IN TIBET IN 1979.
CAME TO TIBETAN HOMES
AT AGE ELEVEN.

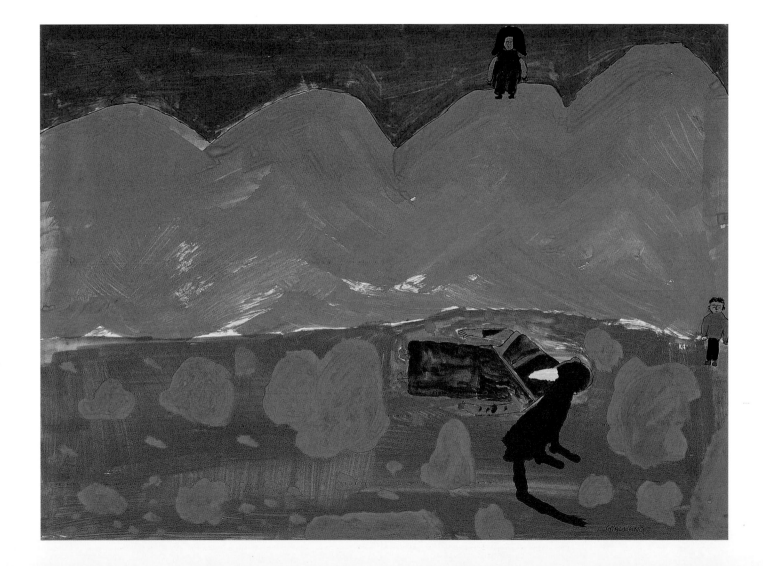

GYALWANG

Born in Tibet in 1979. Came to Tibetan Homes at age eleven.

Why did you decide to come here?

My parents decided to send me to India to get an education because the Chinese dominate the schools in Tibet. The Chinese had opened many casinos in our country and the students were spoiled by drinking and smoking. The majority of young Tibetans are already attached to drinking and smoking. The Chinese provide these things at very cheap prices even for very small children. I would see this every day because I was in school with them. My father heard that in India they have a school and that the head of the school is the Dalai Lama.

Did your parents say, "Son, we think you must leave" and you were gone?

They told me three days before.

Did you want to go?

It was my parents' wish. In Tibet it is considered the best education is in India.

Could you tell your father that you didn't want to go?

No!!!

When did you first leave Tibet? [He made two attempts.]

When I was six years old.

Did you have to leave quickly?

I left two days after my parents told me of their plan.

What happened first when you left your home?

There were three of us. My sister, me, and an old monk who was an old friend of my father who used to stay with us.

Did you take a bus?

Yes.

Did your parents put you on the bus?

Yes. It's actually not a bus but a truck.

Your mother and father both put you on the truck?

They saw me off early, at four in the morning. At that time I was small so they put me in the truck.

Did you say good-bye?

There was not that much time. It was a transport truck.

What was inside the truck?

A few people who carried their own passports.

How many people?

I don't know, I was small. A few. We reached Dam [the border] at night. If we slept at the border we feared we would be caught because they check at night. So we climbed up on the mountain and spent the night there. We cut the grass and laid down. We had no blankets.

Heavy coat?

We wore grass on us.

What were you thinking that night?

I was thinking that soon we would be reaching India because it was dangerous.

Scared

BY GYALWANG
BORN IN TIBET IN 1979.
CAME TO TIBETAN HOMES
AT AGE ELEVEN.

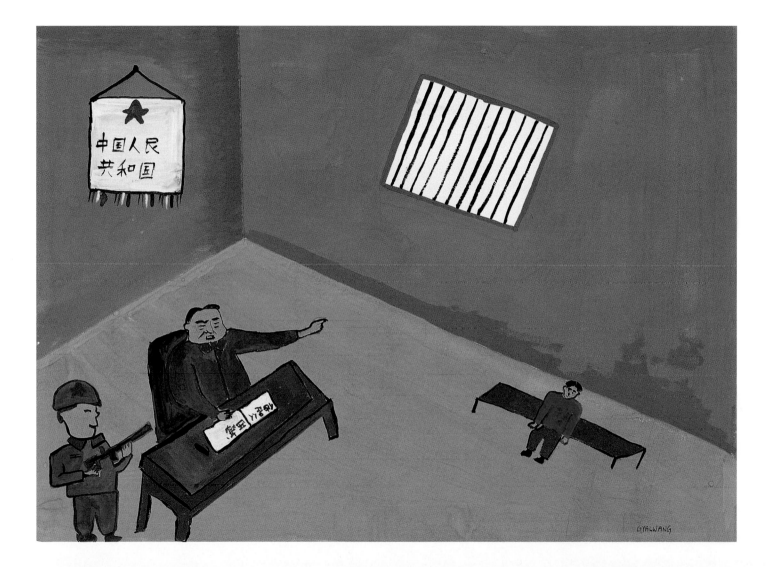

Frightened?

Yes, of being caught by the Chinese.

Thinking of your parents then?

Yes, because I used to sleep so peacefully at home.

How about water and food?

We had *tsampa* with us. For water we had an ice block formed by a glacier in the mountain.

How many hours did you sleep?

Until morning, around 5:30 A.M. We met two Tibetan men working at a power station who knew the way to Nepal. The monk paid them some money to show us the way. It was a very steep slope down to the other road. Because the monk was so much older, around sixty years old, we used a rope to protect us. My sister went first because she was two years older, and we kept the monk between us on the rope. There were no trees on the mountain, there was nothing to hold on to. The stones were slippery and it was extremely steep. We got to the next road and then we reached another mountain. The monk told us he would find the way, but he did not return. I waited for half an hour and we started shouting for him. I shouted *"Gyay, Gyay!"* [an honorific term for a teacher or monk]. No one answered. I went to the other side and saw that the monk had fallen. When I got near, I saw that he was dead. He had a handful of grass with him. I climbed up the mountain to my sister. She told me to search for help and she would stay with the body. [She was eight or nine at the time.] So, when I went to get help, I got lost when it started to get dark. I had no food or water. I cried out for my sister. I was tense. Afraid and sad. I slept the night in a cave that I found. Birds were coming in. Big birds like chickens with a long tail. I slept there. In the morning I realized I was totally lost and returned to the cave. I shouted and shouted for my sister, calling her name. I was there for three or four days without food or water. I didn't wander far from the cave because I was hungry and weak. On the fourth day I went a little bit away from the cave. I heard a man breaking stones. At first I didn't see anyone. I went down the mountain and found a carpenter. Some people told me that I must go to the police and report. I told the police that my sister was with me and I requested they get her as she had no food. The head policeman was Tibetan. The police didn't go, they sent a local person to find my sister. But they didn't find her. I wasn't able to give them good directions as I had lost my way. I never saw my sister then. I was held in Dam by the police for two months.

What was the worst part of the trip?

When I was lost and no one was there and I cried.

Do you have nightmares about that now?

No, but I remember those unforgettable days.

Eventually Gyalwang was returned to his village. Several years later he successfully made the journey to India, where he was reunited with his sister.

One Night's Rest at Nepal Border

BY TSETAN CHOMPEL
BORN IN TIBET IN 1976.
CAME TO TIBETAN HOMES
AT AGE NINE.

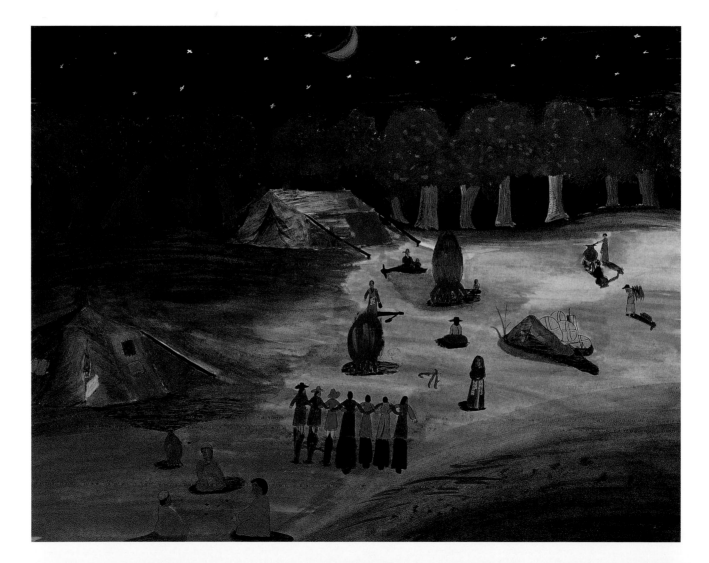

above
MODIFIED TRACTORS AND CARGO
TRUCKS HAVE REPLACED TRADERS
AND YAK TEAMS ON ROADS THAT
WERE ONCE THE TRAILS OF TRAD-
ING ROUTES OUT OF TIBET.

WHILE TRAVEL OUTSIDE OF TIBET IS FORBIDDEN TO MOST TIBETANS, TRAVEL
WITHIN THE COUNTRY ON PILGRIMAGE IS CONSIDERED AN IMPORTANT LIFETIME
EXPERIENCE. IN BORROWED CLOTHING, YOUNG PILGRIMS POSE AT A PORTRAIT
STUDIO IN LHASA. THE PHOTOGRAPHS WILL BE CHERISHED BY FAMILY MEMBERS
BACK HOME. AT LEFT, THE FRIENDSHIP BRIDGE BETWEEN TIBET AND NEPAL.

Swimming Out of Tibet

BY TENZIN JIGME
BORN IN TIBET. CAME TO
TIBETAN HOMES IN 1992.

"It was quite scary, and I was nervous. I don't remember much. As night drew, we had to cross the river, and the vehicle was waiting on the other side. Tibet is on the right and the left-hand side is Nepal. There were a lot of Chinese soldiers everywhere with guns so if they saw us they would shoot. But there were a lot of Tibetans together, so they helped us cross the river. The water was quite cold, but we were wearing thick clothes. In the painting the river is small, but in reality it is quite wide. The water was flowing very fast."

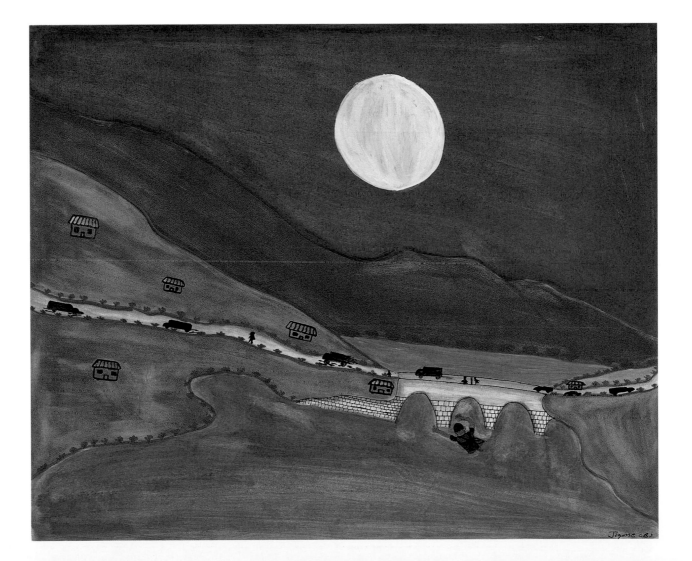

39

On the Way to India

BY GYALTSEN
BORN IN TIBET IN 1980.
CAME TO TIBETAN HOMES
AT AGE TEN.

The Last Good-Bye

BY DACHUNG
BORN IN TIBET IN 1980.
CAME TO TIBETAN HOMES
AT AGE FIVE.

"This is me in purple. This is my dad in brown. These two are my friends in the bus, who came with me to India. They are waiting for me to come to the bus. I am saying good-bye to my father. We are both weeping because it is the last day and I am leaving. The moment is so sad."

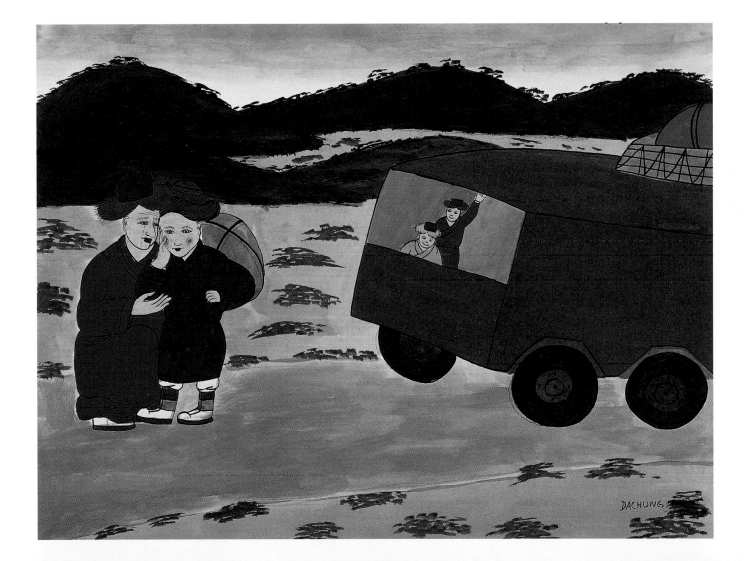

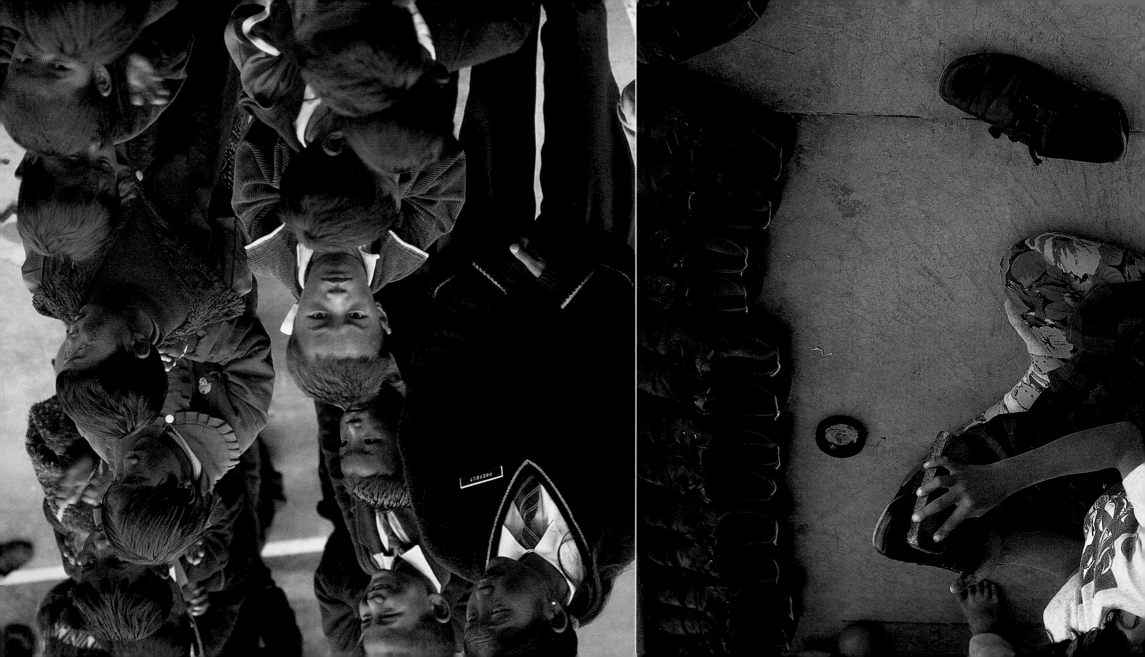

Life in India

RINCHEN PHUNTSOK
Born in Tibet in 1982. Came to Tibetan Homes at age nine.

So, tell me a little bit about your painting, **Playing at Home 27.**

This is the dormitory where I live, Home 27. This is the kitchen [points to a window in the lower right corner].
This is the dining hall, this is the prayer room [upstairs], the foster parents' room, the girls' room, below this is the boys' room.
The girls are playing badminton and skipping rope and this is football.

Me and My Brother Going to School

BY TENZIN PALDON
(PALDONLAK)
BORN IN TIBET IN 1980.
CAME TO TIBETAN HOMES
AT AGE SEVEN.

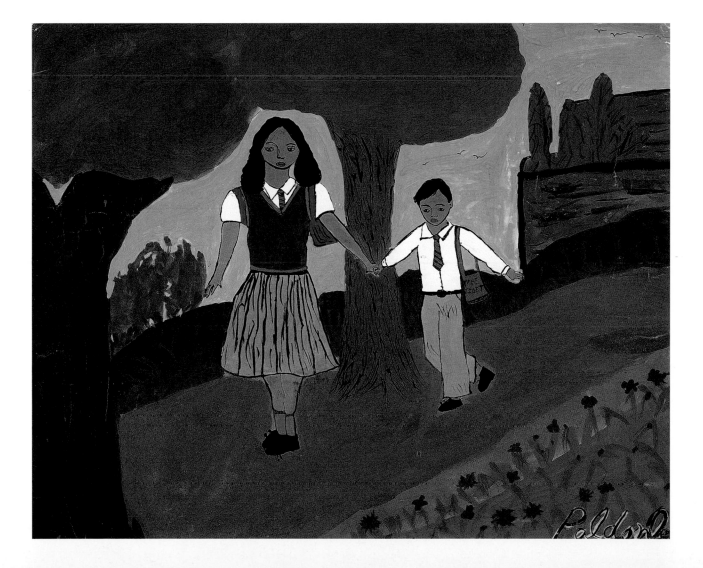

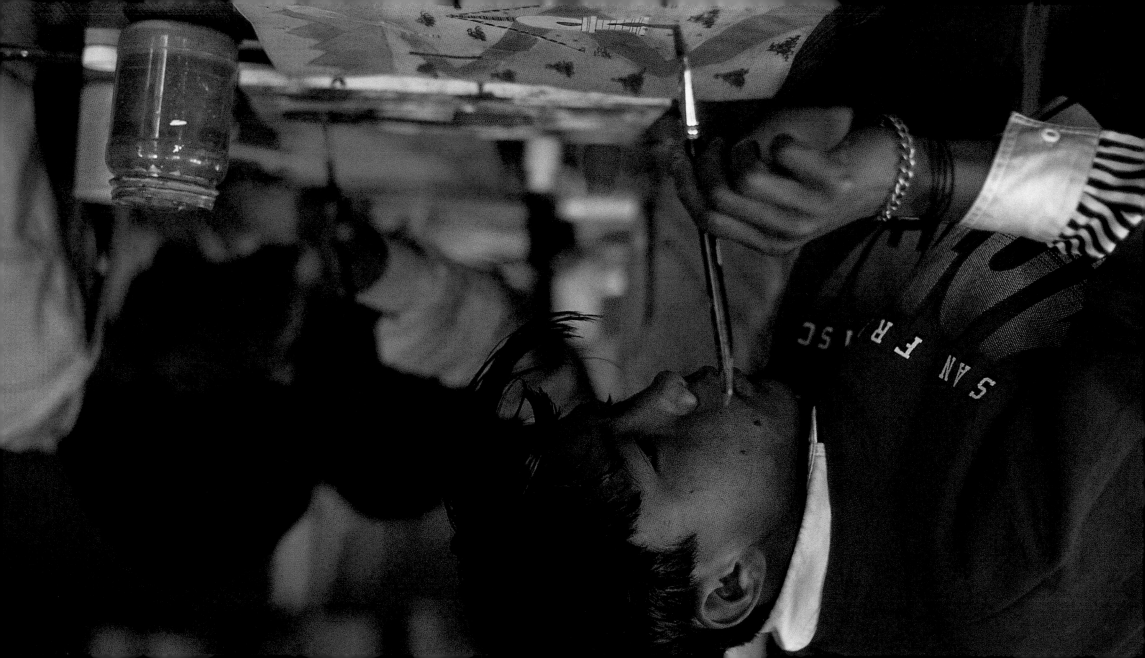

TENZIN LOBSANG, ALMOST COMPLETELY
DEAF, IS AN OIL PAINTING STUDENT.

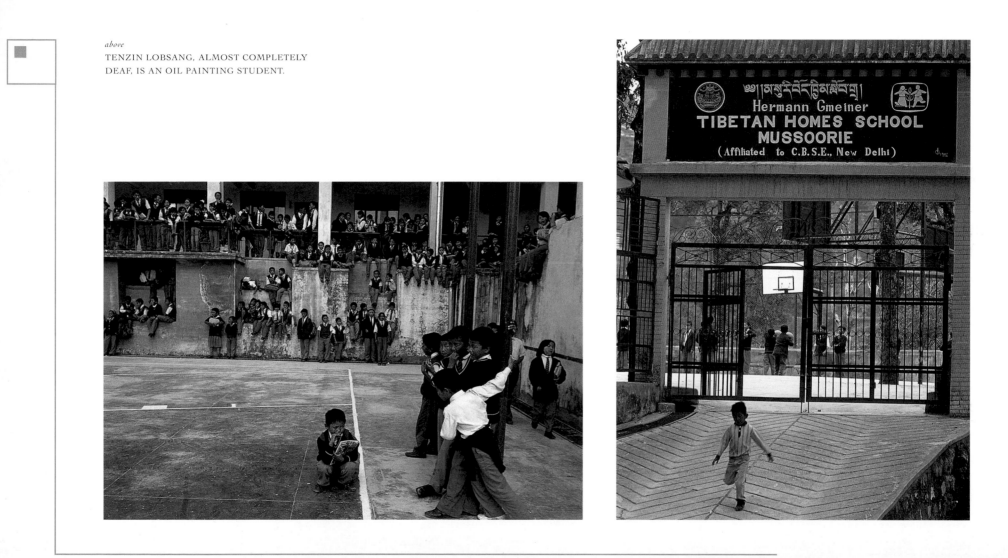

Tibetan Homes Foundation (THF)

BY TENZIN LOBSANG
BORN IN TIBET. CAME TO
TIBETAN HOMES IN 1987.

In the Classroom

BY TENZIN NORBU "A"
BORN IN TIBET IN 1981.
CAME TO TIBETAN HOMES
AT AGE ELEVEN.

Tibetan students are taught by their teachers to study hard in order to create better lives for themselves in exile. Ultimately, education is understood as a way of training children to be more informed about Tibet's role in world affairs, thus putting them in a better position to serve their goal of regaining their homeland.

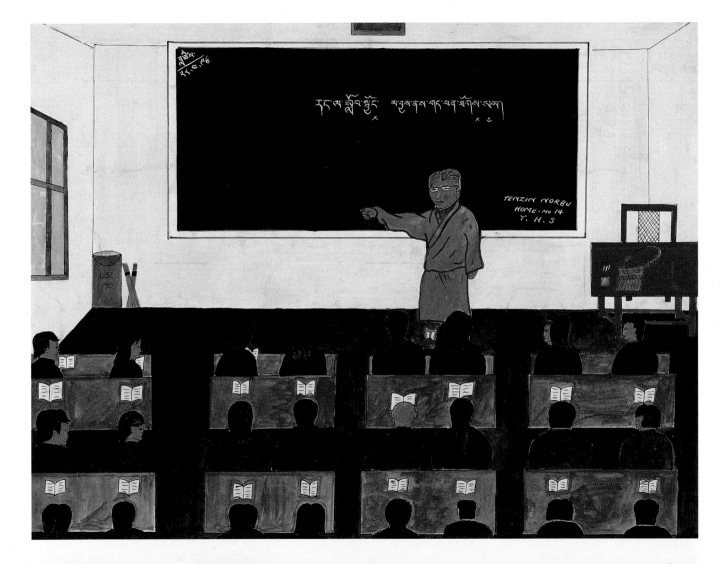

49

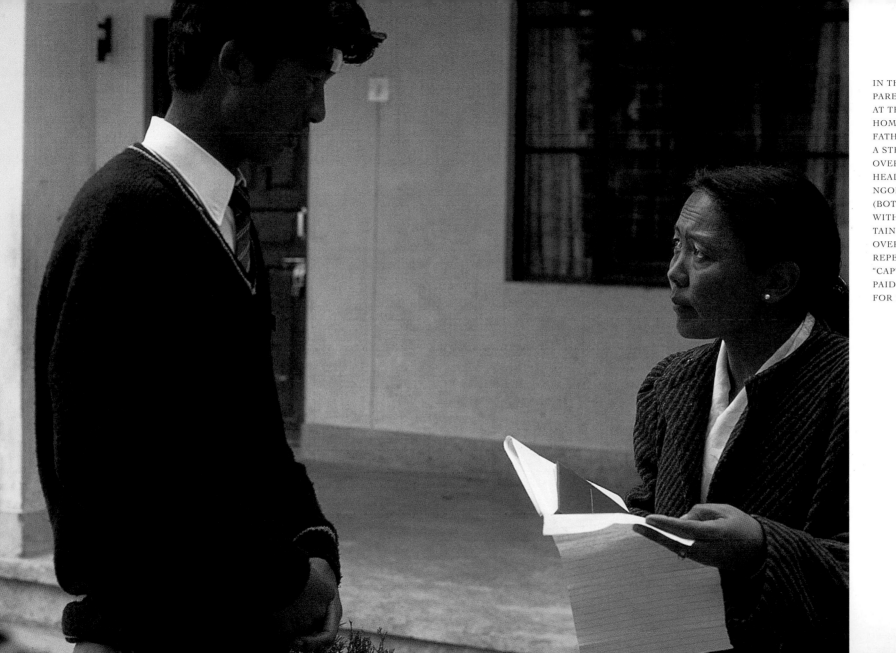

IN THE ABSENCE OF
PARENTS, DISCIPLINE
AT THF IS STRICT. AT
HOME 1, THE HOUSE-
FATHER (TOP) KEEPS
A STERN WATCH
OVER STUDY HALL.
HEADMISTRESS
NGODUP SANGMO
(BOTTOM) CONFERS
WITH STUDENT CAP-
TAIN NYIMA DORJE
OVER A CLASSMATE'S
REPEATED ABSENCES.
"CAPTAIN NYIMA" IS
PAID A SMALL SALARY
FOR HIS DUTIES.

TIBETAN SCHOOL TEAMS IN INDIA TRAVEL TO
MUSSOORIE TO COMPETE IN TRACK AND SOCCER
MATCHES. GENERAL SECRETARY PEMA DECHEN
GORAP PRESENTS THE TROPHY THE YEAR THE VIC-
TORY WENT TO THF.

Playing at Home 27

BY RINCHEN PHUNTSOK
BORN IN TIBET IN 1982.
CAME TO TIBETAN HOMES
AT AGE NINE.

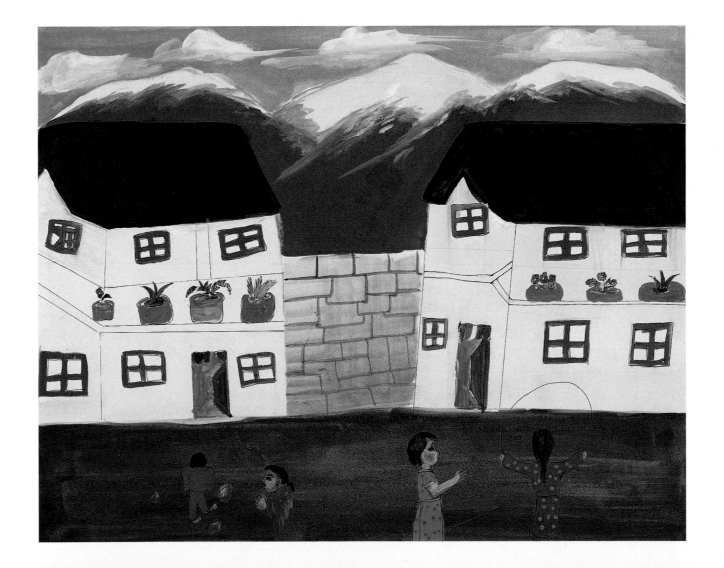

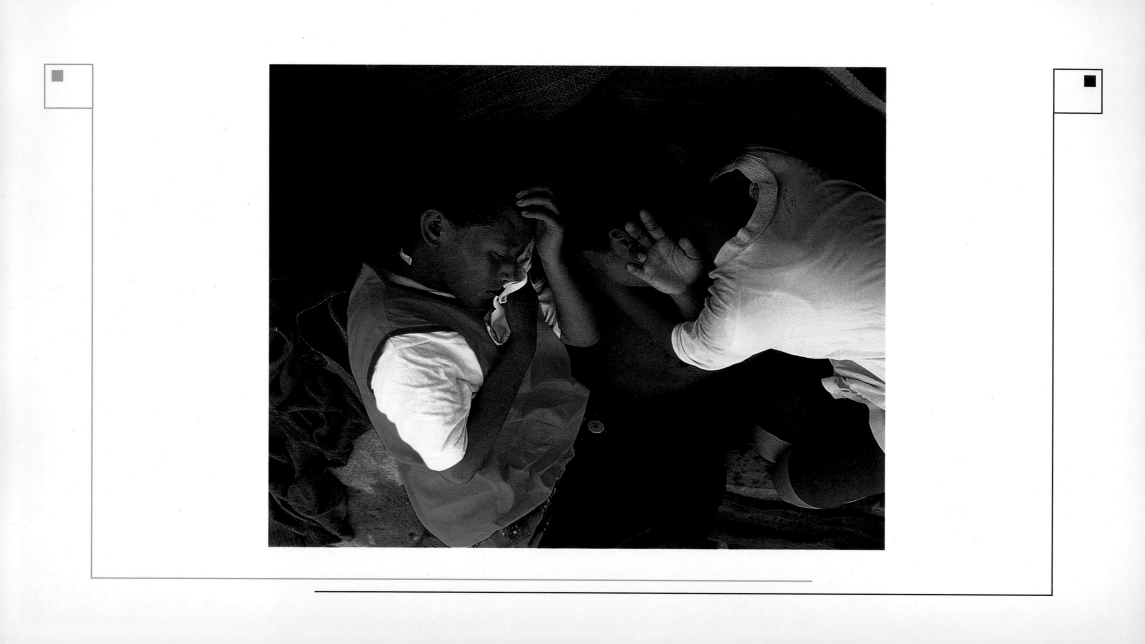

Untitled

BY DACHUNG
BORN IN TIBET IN 1980.
CAME TO TIBETAN HOMES
AT AGE FIVE.

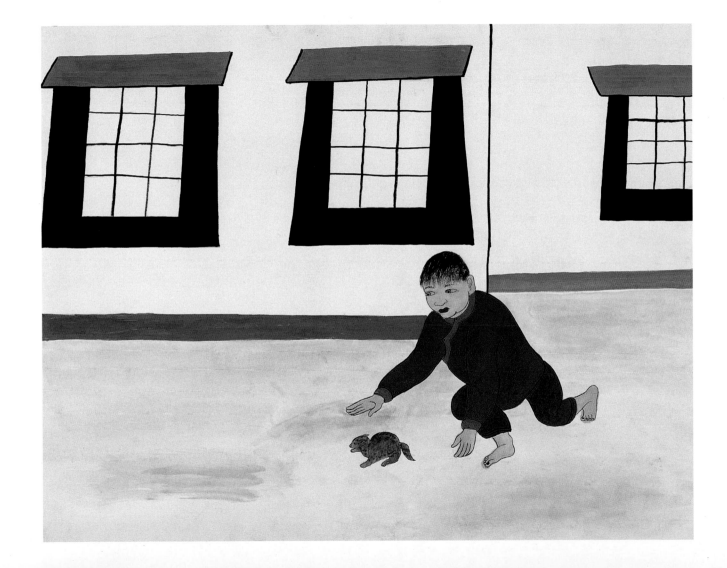

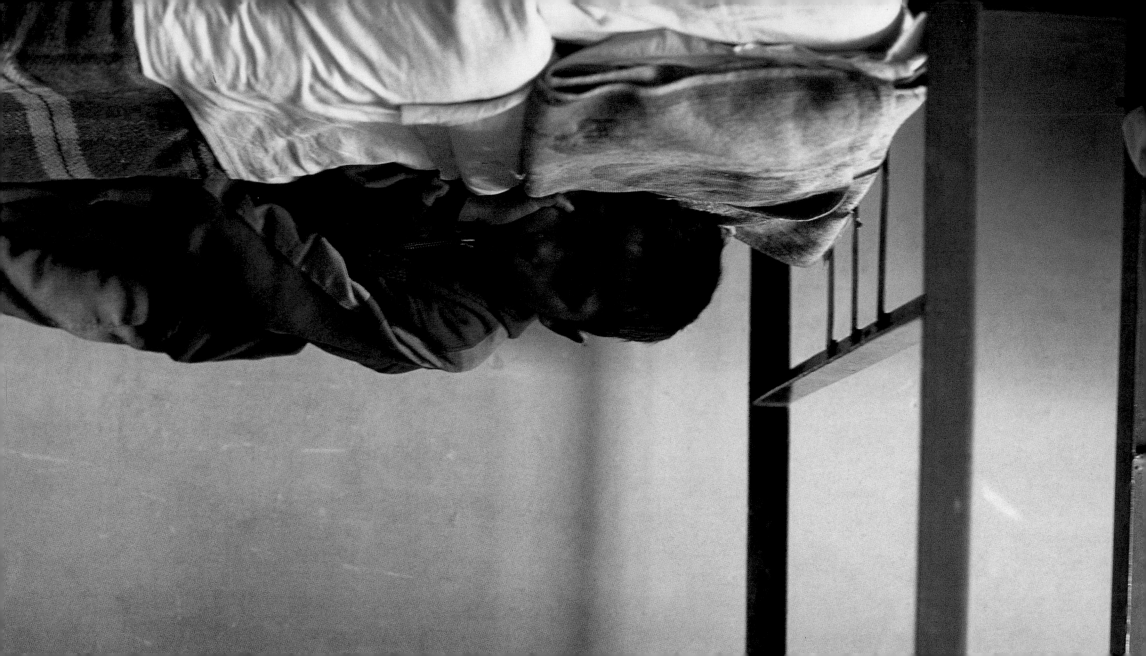

Playing Tricks

BY PEMA GYALTSEN
BORN IN INDIA IN 1977.
CAME TO TIBETAN HOMES
AT AGE THREE.

"It is about a boy who is in his bed. He has already slept. We covered his eyes with a cloth so that when he gets up he can't see anything. He is shocked. Very confused! Actually, in reality, what I did was cover up his spectacles with paper so he couldn't see."

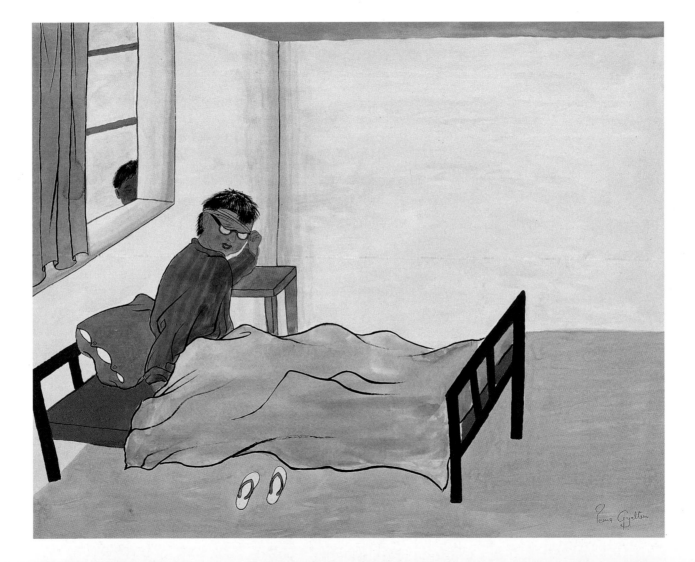

YOUNG STUDENTS PLAY A GAME SIMILAR TO TAG.
OLDER BOYS PLAY CRICKET, A POPULAR GAME IN
INDIA.

I Am Playing Carrom Board

BY TENZIN DHONTEN
BORN IN INDIA IN 1978.
CAME TO TIBETAN HOMES
AT AGE SIXTEEN.

"It's a scene of my settlement in Orissa [eastern India] where I was born and grew up. It is *carrom* board. You try to knock the chips into the holes. The winner is the one who finishes first. My mother is in the doorway. She is carrying a thermos full of tea."

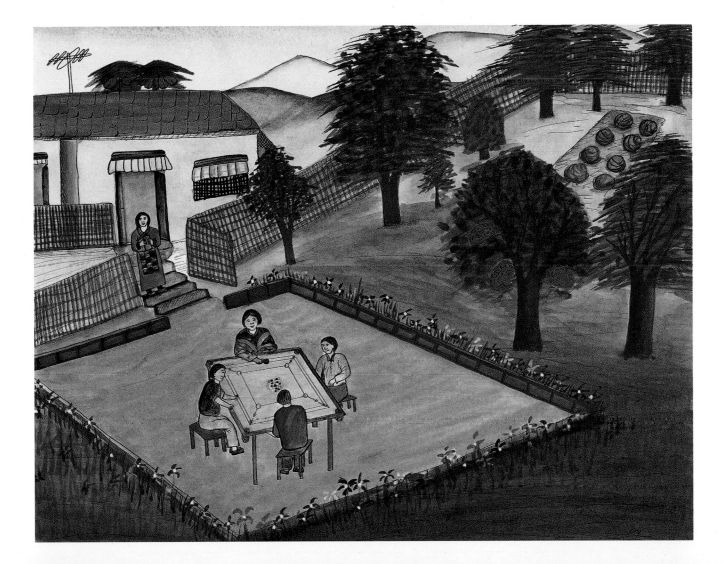

Weaving Carpets

BY THUPTEN SANGYAL
BORN IN INDIA.

Selling Sweaters on the Mussoorie Mall

**BY THUPTEN SANGYAL
BORN IN INDIA.**

Tibetan entrepreneurs sell Indian factory-made sweaters throughout the country, moving from town to town as the market demands.

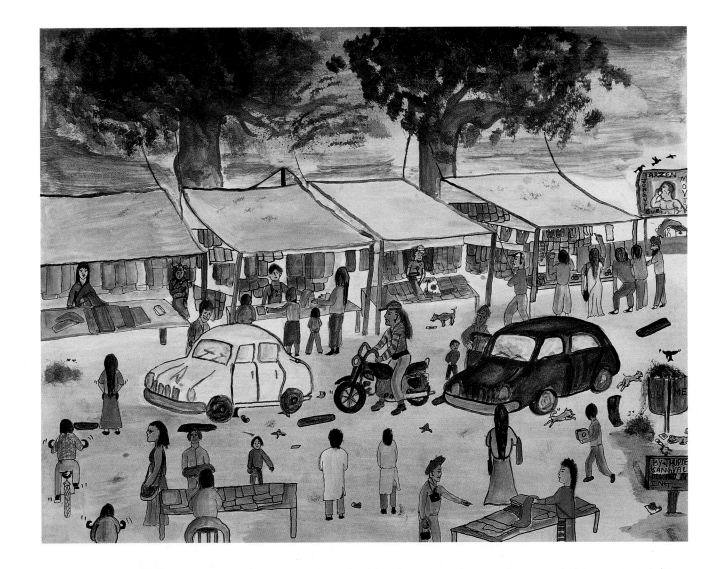

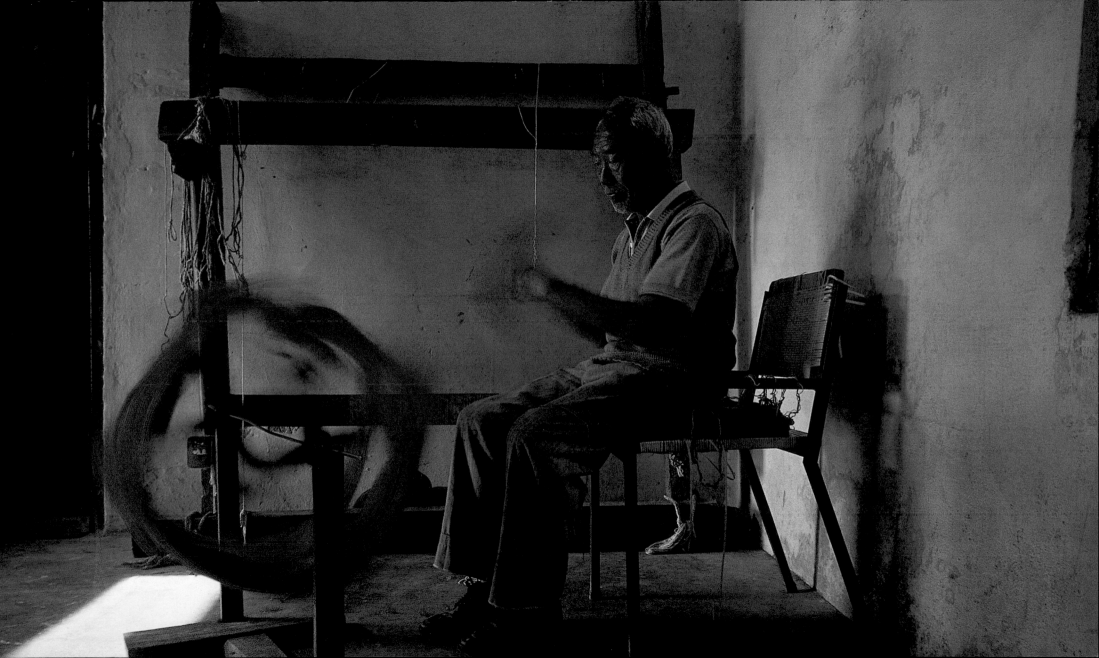

Untitled

**BY LOBSANG SANGAY
BORN IN TIBET IN 1975.**

previous pages
A MAIN SOURCE OF INCOME FOR
TIBETANS LIVING IN INDIA IS IN
THE HANDICRAFT INDUSTRIES, IN
CARPETMAKING AND SWEATER
SELLING.

Sangsol at THF

BY LOBSANG SANGAY
BORN IN TIBET IN 1975.

This painting depicts *sangsol* [prayer offering] being performed on Dalai Hill in Mussoorie, India. Dalai Hill is named after the famous hill in Lhasa, Tibet, where, according to legend, Songsten Gampo, a famous king of Tibet, used to walk and pray. His prayer ground has an honored place in the Potala Palace, former residence of the Dalai Lama.

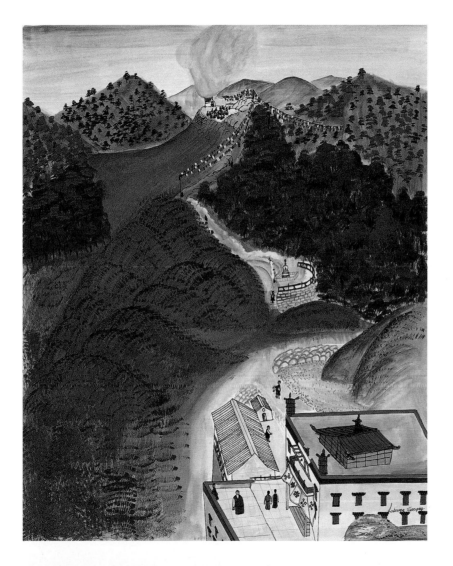

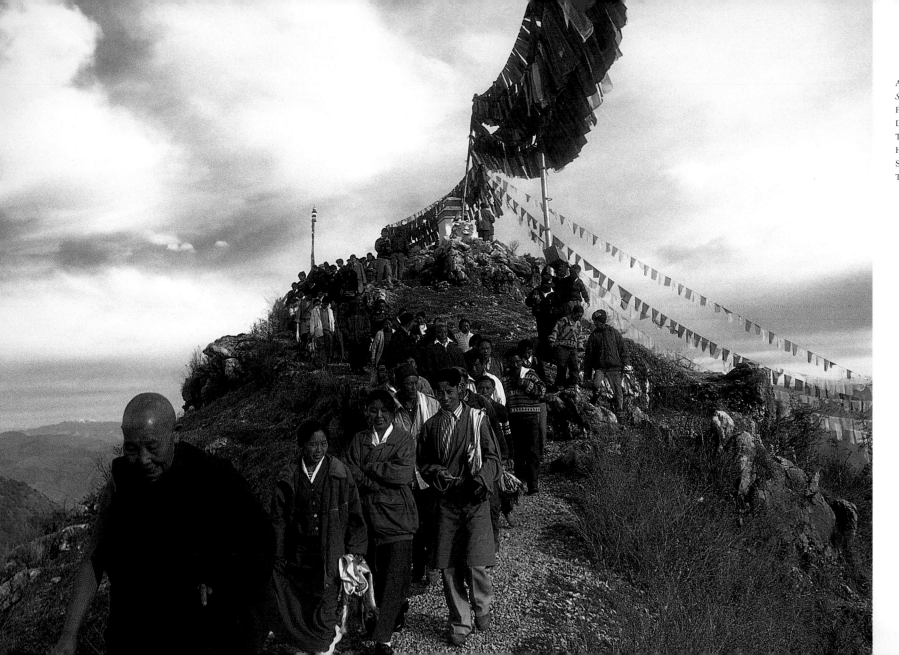

A SUNRISE
SANGSOL IS
PERFORMED ON
DALAI HILL AT
THF TO PRAY FOR
HIS HOLINESS'
SAFE JOURNEY TO
TAIWAN.

PART THREE

Remembering Home

THAKCHOE
Born in Tibet in 1979. Came to Tibetan Homes at age seven.

Thakchoe, we're looking at your picture,* Setting Up a Picnic Tent. *Are you in this picture?
Yeah, I am in purple, pulling the rope of the tent. I have on a hat and Tibetan boots. My dad is in the blue shirt and red *chuba* and he's trying to hammer the stake of this tent.

He's a big guy. Is he a big guy in real life?

Yeah!

And your mom?

She went to fetch water and she is wearing a blue *chuba* and a yellow shirt. With her in green is a neighbor who has come together for the picnic. The neighborhood kids are helping to set up the tent, and the guy inside the tent is my elder brother. The guy in the left corner in yellow is preparing stakes for the tent, and this guy is preparing nails for the tent.

So, all these things behind your dad here, there's a butter churner and a momo steamer and what's this round thing?

A utensil for making tea. This white bag is *tsampa* and in the blue pack is bedding and blankets. During the picnic we have food and we play. We carry the tent and we go far away and we stay for two or three days. We walk there.

Do you remember this? Is this a real event?

[Laughter] Maybe a little bit.

previous page
DWARFED BY A HUGE FABRIC OF SILK, LAYMEN ASSIST IN THE UNVEILING OF AN ENORMOUS *THANGKA* IN LHASA. FOR THE FIRST TIME SINCE 1959, THE *THANGKA* WAS HUNG BRIEFLY IN FRONT OF THE POTALA PALACE DURING A SUMMER FESTIVAL IN AUGUST 1994 TO COMMEMORATE COMPLETION OF THE PALACE'S RESTORATION.

Churning Tea in Tibet

BY KARMA LODOE
BORN IN NEPAL IN 1977.
CAME TO TIBETAN HOMES
AT AGE SEVEN.

Here is a typical scene of making Tibetan tea with a churn, a pervasive activity in Tibet. The design on the side of the tent is called *pata*, the eternal knot symbolizing the Buddha's mind. Like the design, all people are interconnected.

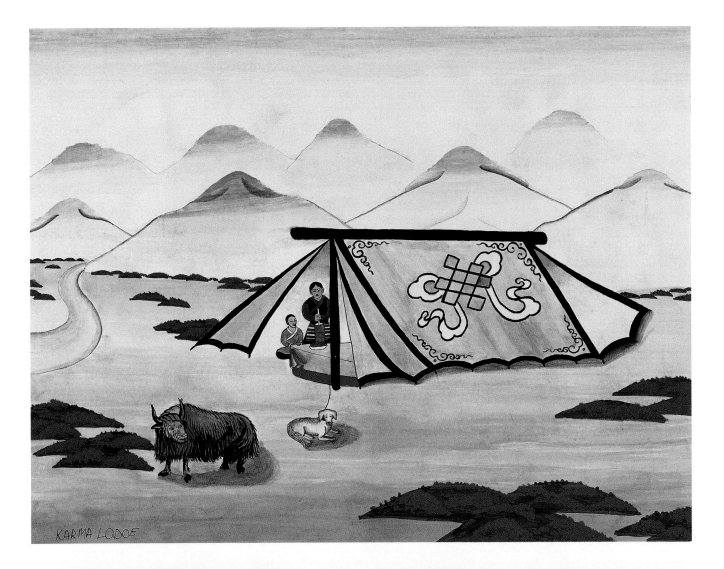

71

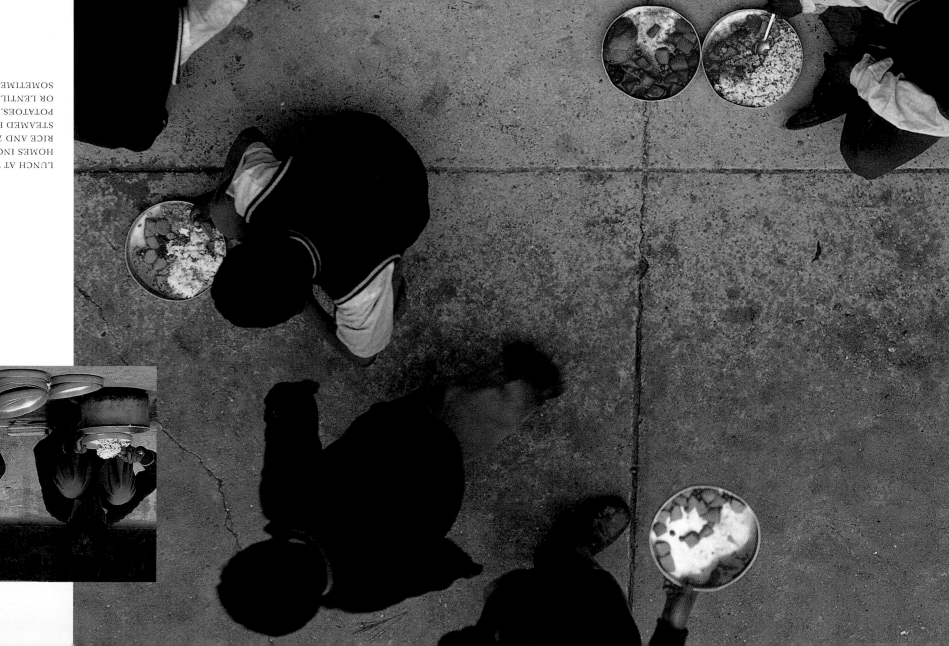

LUNCH AT THE
HOMES INCLUDES
RICE AND *TIGMO* (A
STEAMED BUN) WITH
POTATOES, SPINACH,
OR LENTILS AND
SOMETIMES FRUIT.

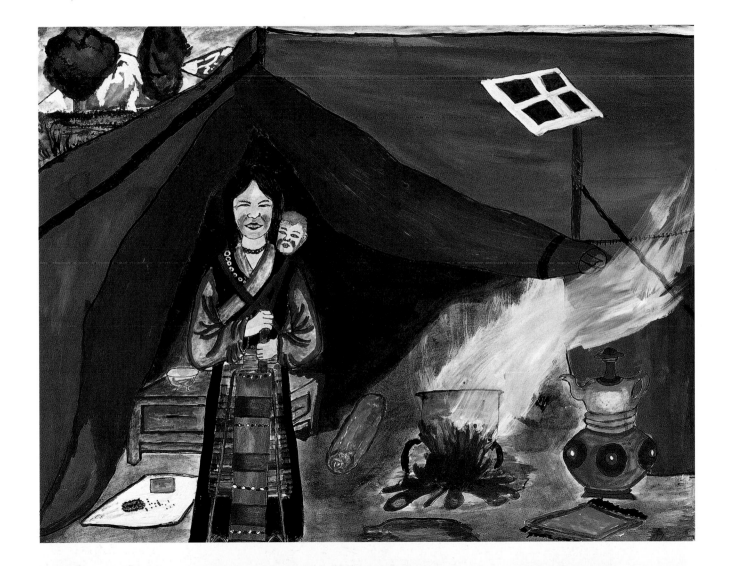

Making Tibetan Tea

BY THUPTEN SANGYAL
BORN IN INDIA.

Tibetan Kitchen

BY NGAWANG CHODAK
BORN IN TIBET IN 1979.
CAME TO TIBETAN HOMES
AT AGE FIVE.

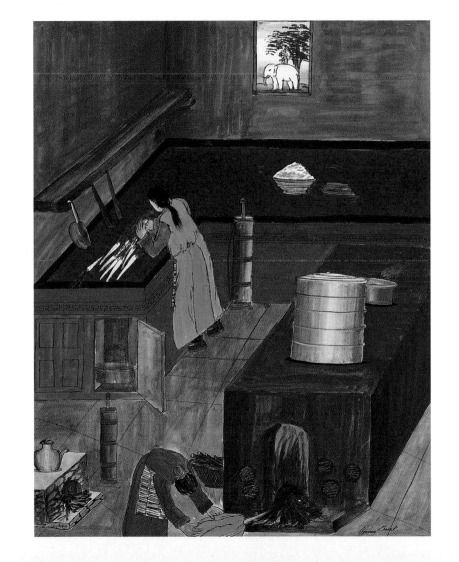

Gathering Wood

BY THAKCHOE
BORN IN TIBET IN 1979.
CAME TO TIBETAN HOMES
AT AGE SEVEN.

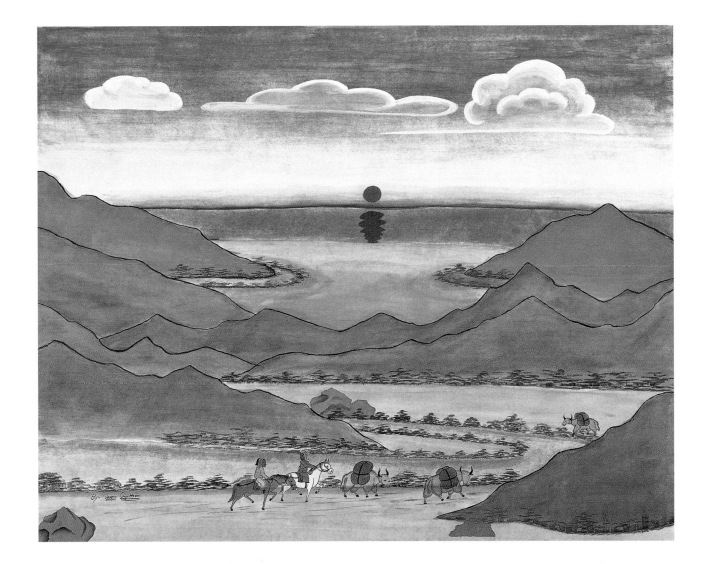

Yak Team

BY JAMPA GYALTSEN
BORN IN NEPAL IN 1978.
CAME TO TIBETAN HOMES
AT EIGHT MONTHS.

PEMA GYALTSEN PAINTS A WRATHFUL DEITY IN *THANGKA* PAINTING CLASS. HE HOPES TO FIND A TEACHING JOB ONCE HE COMPLETES HIS TRAINING. DORNAM (AT RIGHT) IS THE *THANGKA* TEACHER AT VTC.

Woman Riding Yak

BY PEMA CHOSANG
BORN IN INDIA IN 1970.
CAME TO TIBETAN HOMES
AT AGE ELEVEN.

Pema, born in a refugee camp located in Assam, India, is studying *thangka* painting, as the style of this work suggests. Here, he depicts a nomadic woman from Amdo, whose distinctive clothing includes a *gyabtar* hanging down her back. The Amdo *gyabtar* is worn by a woman who is over eighteen, signifying that she is now a woman who is able to live in her own tent.

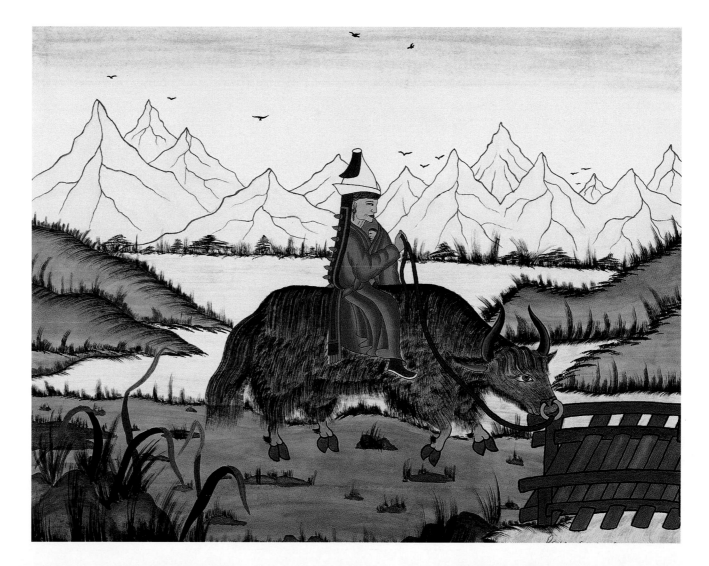

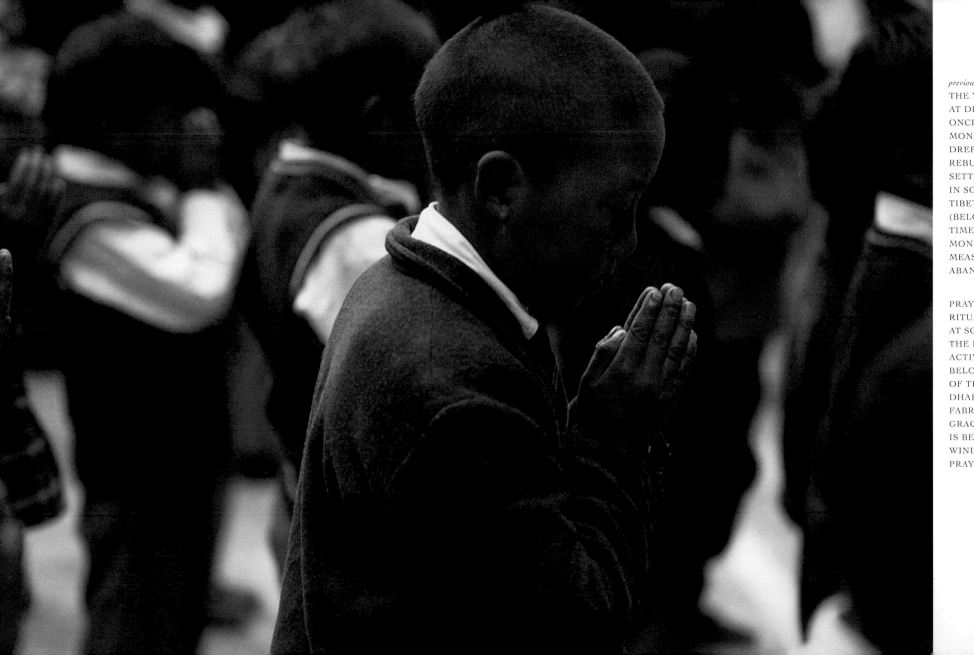

THE YOUNGEST MONKS
AT DREPUNG MONASTERY.
ONCE THE LARGEST
MONASTERY IN TIBET,
DREPUNG HAS BEEN
REBUILT IN THE TIBETAN
SETTLEMENT OF MUNGOD
IN SOUTHERN INDIA.
TIBETAN NEW YEAR
(BELOW) IS A FESTIVE
TIME WHEN THE YOUNG
MONKS ARE ALLOWED A
MEASURE OF PLAYFUL
ABANDON.

PRAYER IS AN IMPORTANT
RITUAL IN DAILY LIFE.
AT SCHOOL IT IS ONE OF
THE FIRST AND LAST
ACTIVITIES OF EACH DAY.
BELOW THE RESIDENCE
OF THE DALAI LAMA IN
DHARAMSALA, COLORFUL
FABRIC PRAYER FLAGS
GRACE THE HILLSIDE. IT
IS BELIEVED THAT THE
WIND WILL CARRY THE
PRAYERS.

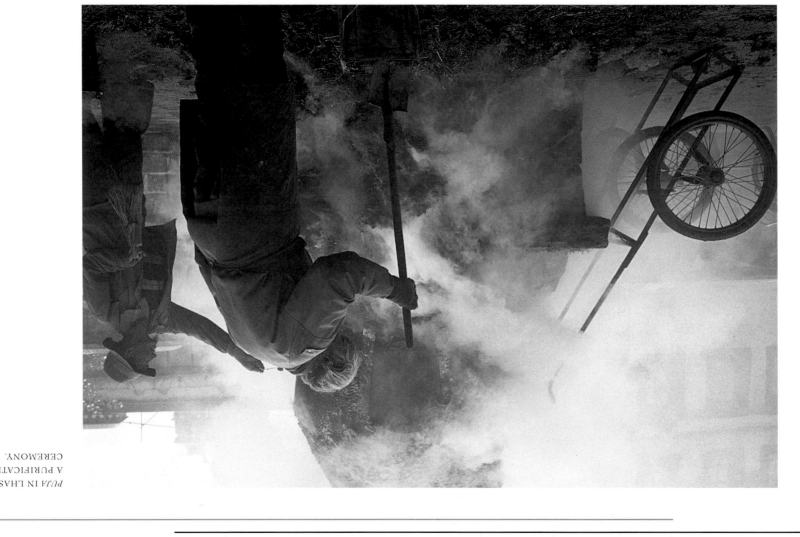

PUJA IN LHASA,
A PURIFICATION
CEREMONY.

Sangsol in Tibet

BY PHUNTSOK TSERING
BORN IN INDIA IN 1974.
CAME TO TIBETAN HOMES
AT AGE TWENTY-ONE.

"It shows my family members.
My father is in the brown *chuba*
[robe] with the white shirt. My
mother has the red shirt, and in
the yellowish brown shirt is an
uncle. So is the other man, an
uncle. These two are monks. This
is during Losar time; we used to
go for *sangsol*. I don't know
[what it means], but I know that
it is a prayer to live longer and to
keep bad things away. To pray to
God for whatever you wish.
After finishing the prayer, you
are given flour or *tsampa*. You
raise your hand up with the flour,
saying 'soooooooooo . . .' three
times. Everybody's shouting.
Then, the third time, everyone
throws the flour."

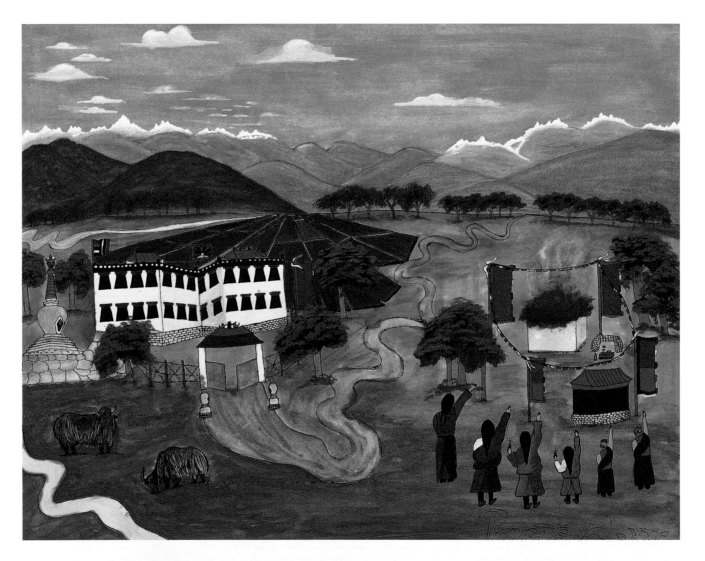

85

Making Kabsay [fried bread made at Losar]

BY NGAWANG CHODAK BORN IN TIBET IN 1979. CAME TO TIBETAN HOMES AT AGE FIVE.

Losar Altar

BY DORJEE GYALTSEN
BORN IN INDIA. CAME TO
TIBETAN HOMES IN 1996.

Losar altars are specially constructed each year and left intact for the first fifteen days of the month.

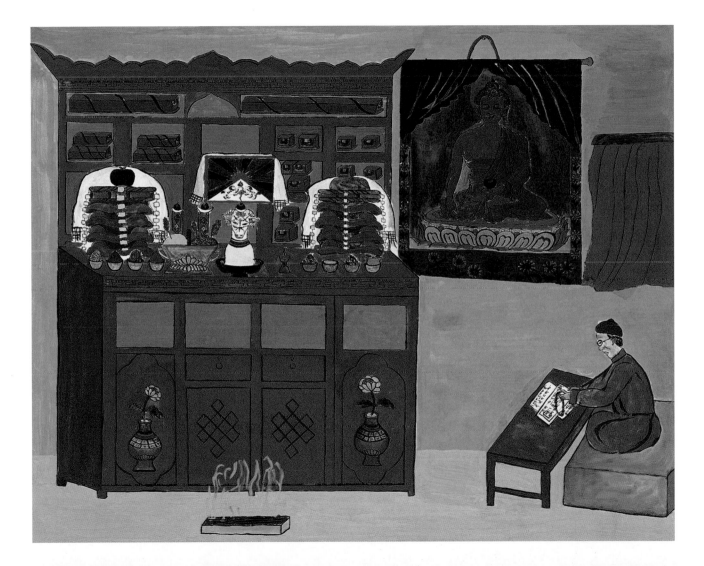

Portrait of Mom

BY TENZIN PALDON
(PALDONLAK)
BORN IN TIBET IN 1980.
CAME TO TIBETAN HOMES
AT AGE SEVEN.

Paldonlak was very fond of
her mother, and when she
heard of her death, she risked
her own life to return to her
homeland. This painting was
done from memory before she
received the news.

Losar Meal

BY TENZIN NORBU "C"
BORN IN INDIA IN 1978.
CAME TO TIBETAN HOMES
AT AGE SIX.

The painting is about serving
guthuk, a festive noodle soup
served only during Losar, the
Tibetan New Year.

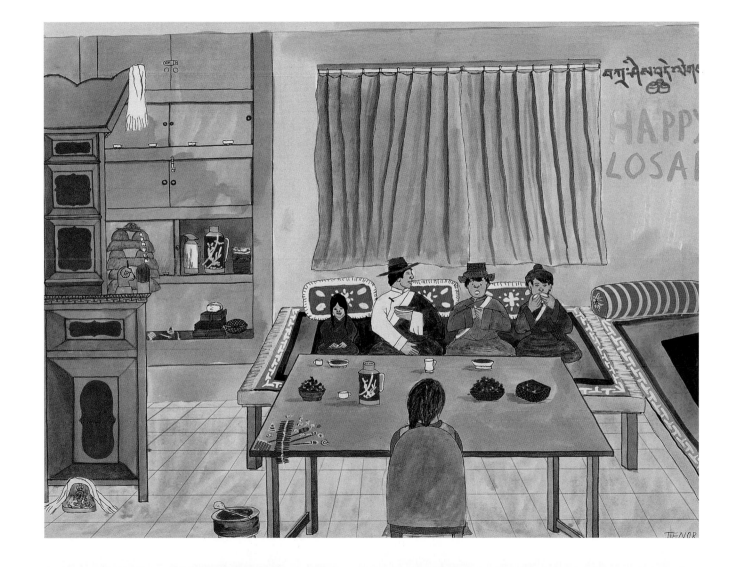

Mother and Child

**BY TSERING NGODUP
BORN IN INDIA IN 1980.
CAME TO TIBETAN HOMES
AT AGE FIFTEEN.**

"The boy is holding a bird in his hand and Mom is telling him not to kill it, to have pity on it."

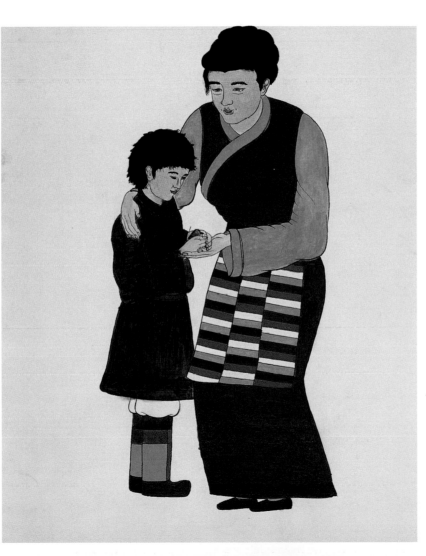

above

TSERING LHAMO IS A TIBETAN ELDER LIVING AT THE OLD PEOPLE'S HOME IN RAJPUR, INDIA, WHICH IS ADMINIS-TERED BY TIBETAN HOMES FOUNDATION. ALTHOUGH SHE IS ALMOST COMPLETELY BLIND, SHE STILL HAS THE GIFT OF INSIGHT, OR *MO*, A MAGICAL ABILITY TO SEE BEYOND WHAT IS KNOWN.

Women Dancing

BY TENZIN PALDON
(PALDONLAK)
BORN IN TIBET IN 1980.
CAME TO TIBETAN HOMES
AT AGE SEVEN.

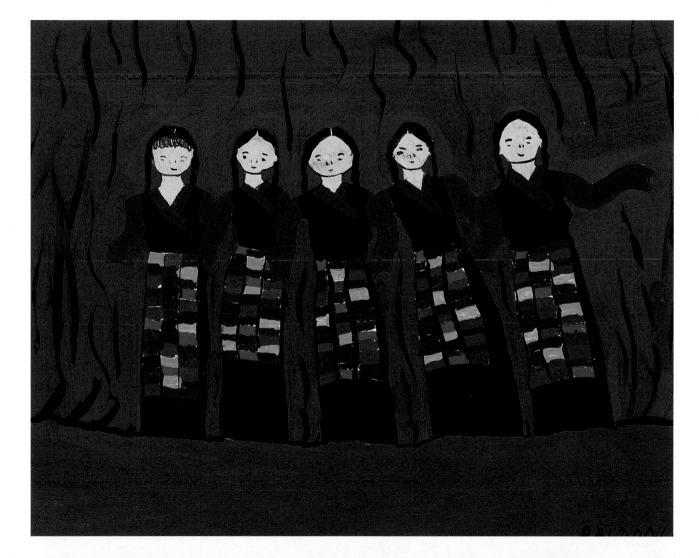

above
AT THE HOMES, TIBETAN
DANCE AND TRADITIONAL
COSTUMES ARE IMPORTANT
TO PRESERVING CULTURE.

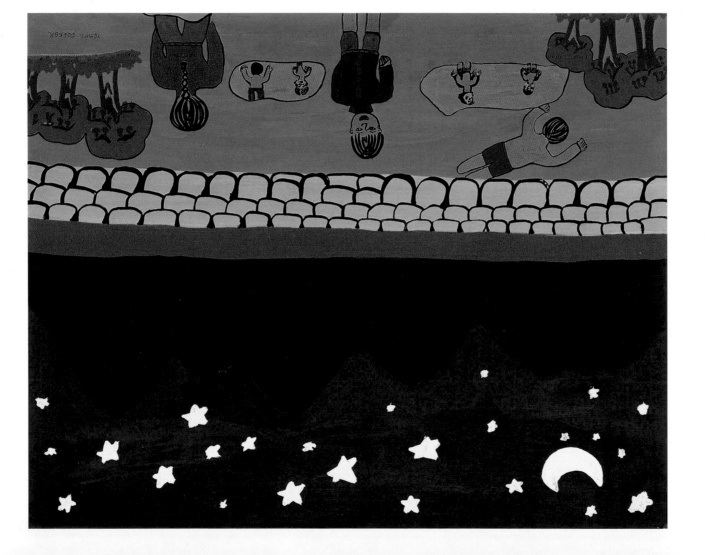

Star Festival

BY YESHI DOLKER
BORN IN TIBET IN 1980.

"Most clearly I remember the times that we used to bathe in the sacred water place during *Karma Dopa* [star festival]. It lasts for about ten days and everyone bathes in the holy water after sunset, as it is considered to remove the illness that a person is suffering. The stars make the water sacred. They give blessings to the water. First my parents bathed us. Then, after drying us up, they go off to swim. Then we played while our parents washed clothes and carpets."

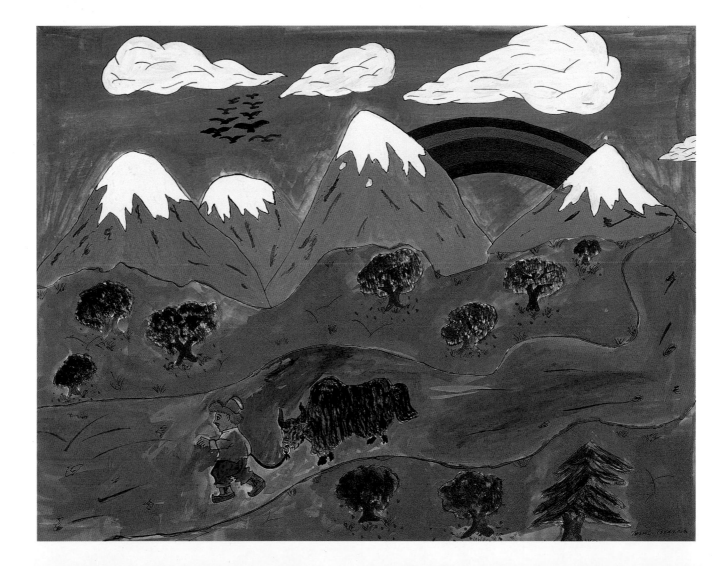

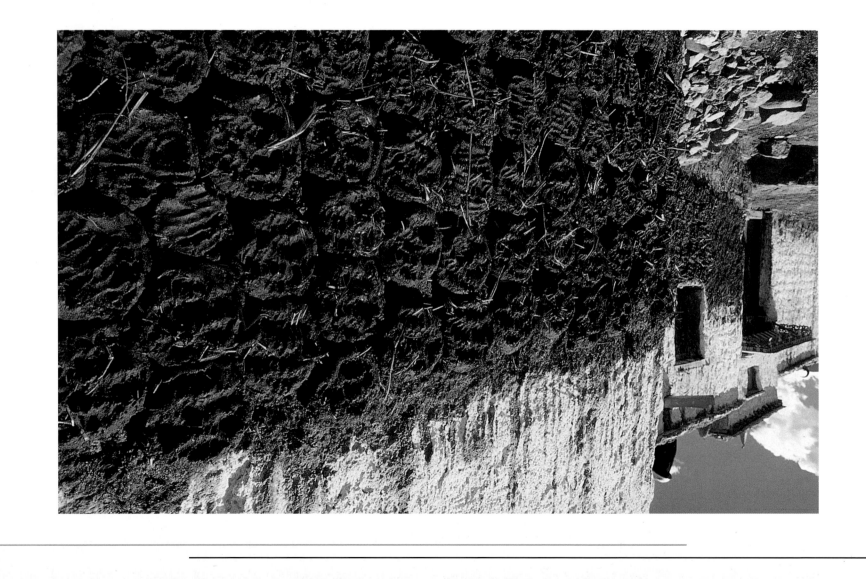

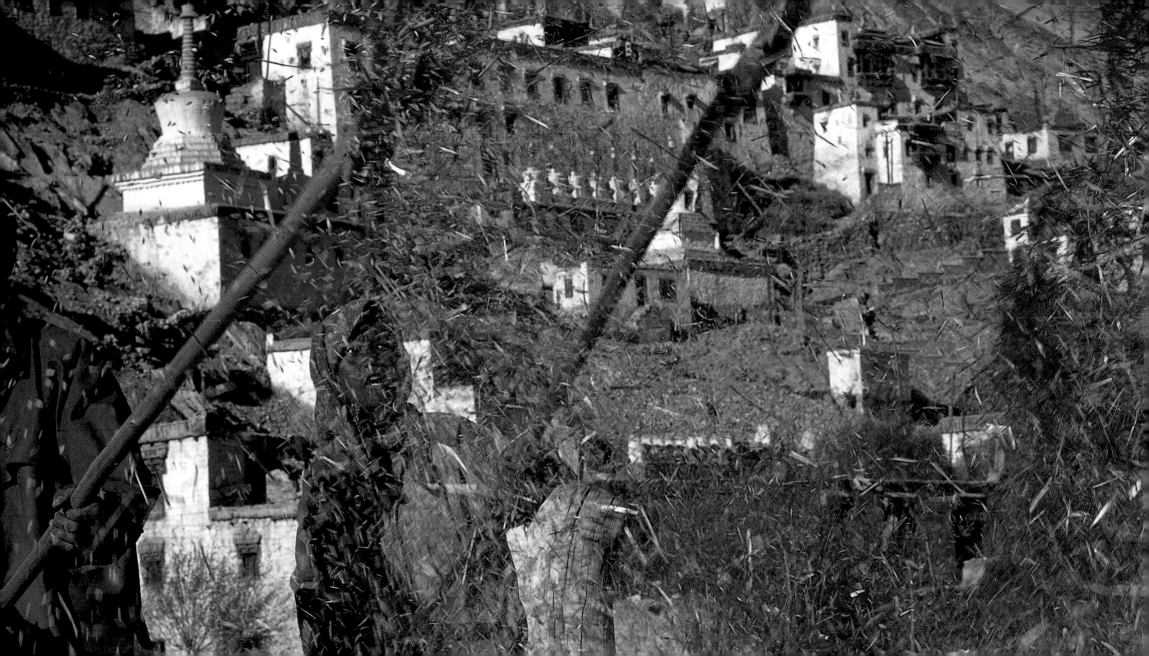

Tobgyal Wins
the Yak Race

BY NGAWANG CHODAK
BORN IN TIBET IN 1979.
CAME TO TIBETAN HOMES
AT AGE FIVE.

In this painting the artist visu-
ally recounts one of his fondest
memories, that of his brother
winning a yak race back home.

previous pages
AT HIGH ALTITUDES, TIMBER IS
SCARCE AND YAK DUNG IS THE
MAIN SOURCE OF FIRE FUEL,
DRIED ON THE WALLS OF A
VILLAGE HOUSE NEAR LHASA.
BELOW TIKSE MONASTERY IN
LADAKH, MODELED AFTER THE
POTALA, VILLAGERS SING HARVEST
SONGS WHILE THRESHING BARLEY,
ONE OF THE FEW CROPS THAT
WILL GROW AT SUCH ALTITUDES.

Gathering Yak Dung

**BY LOBSANG SANGAY
BORN IN TIBET IN 1975.**

The yak has always been a
central part of the Tibetan
economy. Even its dung is
gathered and dried to be used
as fuel. This daily activity must
surely be a pervasive theme in
many of these children's minds
when they reflect upon life as
it used to be back home.

Plowing Field

BY DACHUNG
BORN IN TIBET IN 1980.
CAME TO TIBETAN HOMES
AT AGE FIVE.

"Here my father is busy in the field. I have brought food for him and I am watching him at work."

above
BARLEY IS HARVESTED IN FIELDS OUTSIDE OF LHASA. AFTER IT IS ROASTED AND GROUND INTO *TSAMPA*, IT IS MIXED WITH BUTTER INTO A PASTE THAT FORMS A MAINSTAY OF THE TIBETAN DIET.

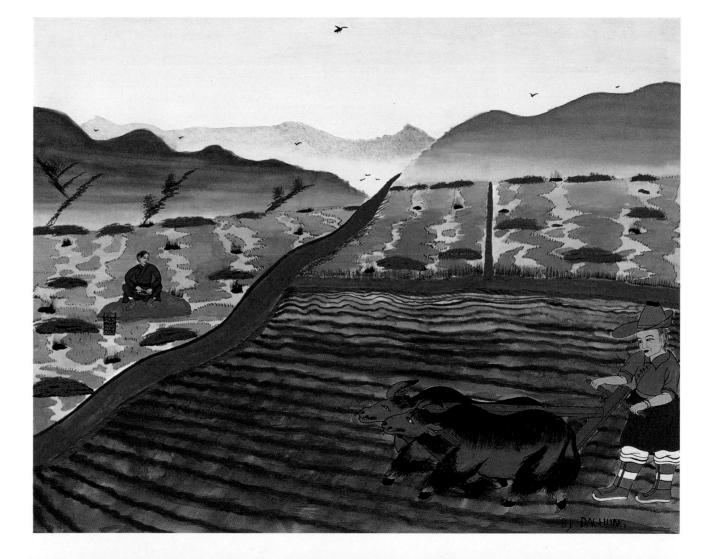

Picnic

BY THAKCHOE
BORN IN TIBET IN 1979,
CAME TO TIBETAN HOMES
AT AGE SEVEN.

Picnics are important leisure-time activities for Tibetans. It is a time for family and friends to gather together, share food, and enjoy nature. Here we see children playing tug-of-war in the background while the adults sit on rugs and play games. They are probably gambling, which has been a national pastime in Tibet for many centuries.

Setting Up a Picnic Tent

BY THAKCHOE
BORN IN TIBET IN 1979.
CAME TO TIBETAN HOMES
AT AGE SEVEN.

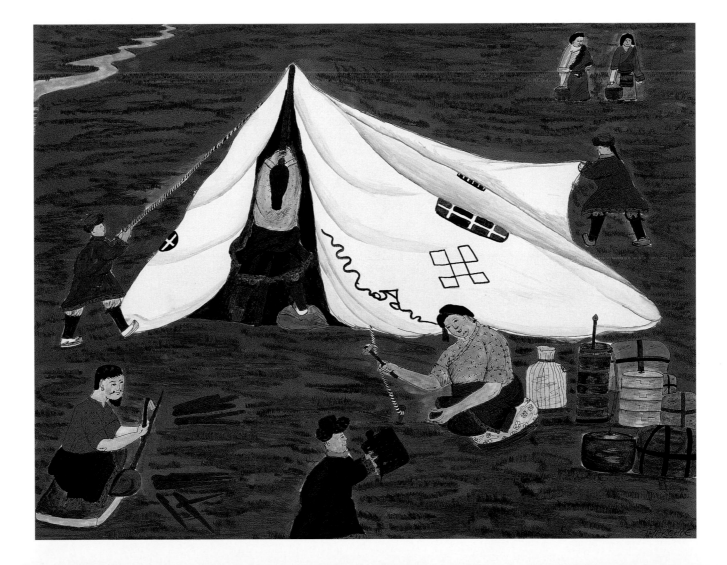

Khampa Warriors at Stupa

**BY PHURBU TSERING
BORN IN INDIA IN 1975.
CAME TO TIBETAN HOMES
AT AGE SIXTEEN.**

The province of Kham in
eastern Tibet is known for its
brave soldiers. Many people
from Kham formed a guerrilla
movement to resist the Chinese
occupying forces after the
Dalai Lama fled his homeland
in 1959. This painting depicts
both the heroic Khampa war-
rior and the numerous *stupas*
[reliquary shrines] that dot the
Tibetan landscape.

above
THE HILLS OUTSIDE TINGRI, TIBET,
IN THE PROVINCE OF KHAM.

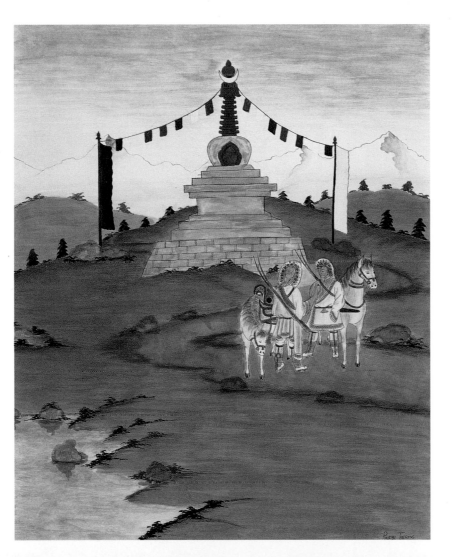

Political Paintings

KARMA SOPA

Born in Nepal in 1980. Came to Tibetan Homes at age five.

Why did you paint this (Tibet Bleeds)?

I painted this because I had heard about the Chinese fooling the Tibetans and making them suffer. I imagined all that, so I painted it. I painted the map of Tibet as Tibet was very rich earlier. The holding of hands shows that the other countries are with us but the Chinese are not letting us free from their grip. The hand represents China trying to bleed dry Tibet.

Chinese Soldier with Dead Yak

BY TENZIN NORBU "A"
BORN IN TIBET IN 1981.
CAME TO TIBETAN HOMES
AT AGE ELEVEN.

Ecological problems, defor-
estation, pollution, and the
decimation of animal popula-
tions are popular topics of dis-
cussion in Tibetan diasporic
communities. Tibetans com-
monly associate these prob-
lems with the Chinese
takeover of their country.

previous page
A CHINESE SOLDIER IN XINING,
QINGHAI PROVINCE, ONCE PART
OF NORTHERN TIBET.

Tibet Enslaved

BY TENZIN LOBSANG

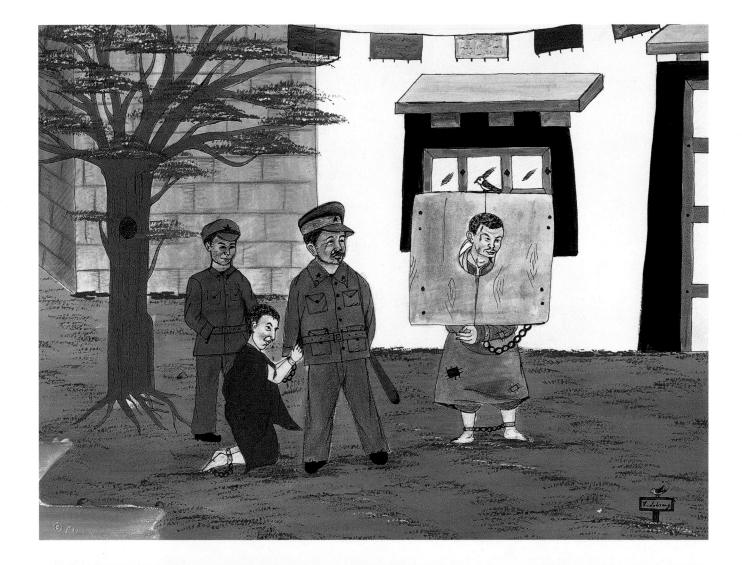

FOR PILGRIMS AND
TRADERS, THE
JOKHANG, TIBET'S
MOST SACRED TEM-
PLE, IS THE HEART
OF LHASA.

Tibet Bleeds

BY KARMA SOPA
BORN IN NEPAL IN 1980.
CAME TO TIBETAN HOMES
AT AGE FIVE.

"The hand represents China trying to bleed dry Tibet. I have painted the sides black because the Chinese torture Tibetans in such a way that it is not visible to others. The darkness represents the evil work of the Chinese, which is done very quietly. I drew that in black because the Chinese are killing the Tibetan people."

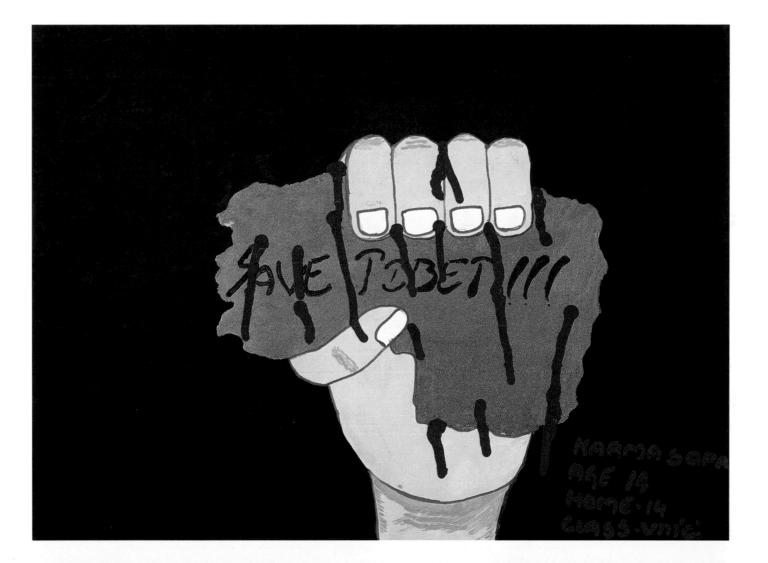

111

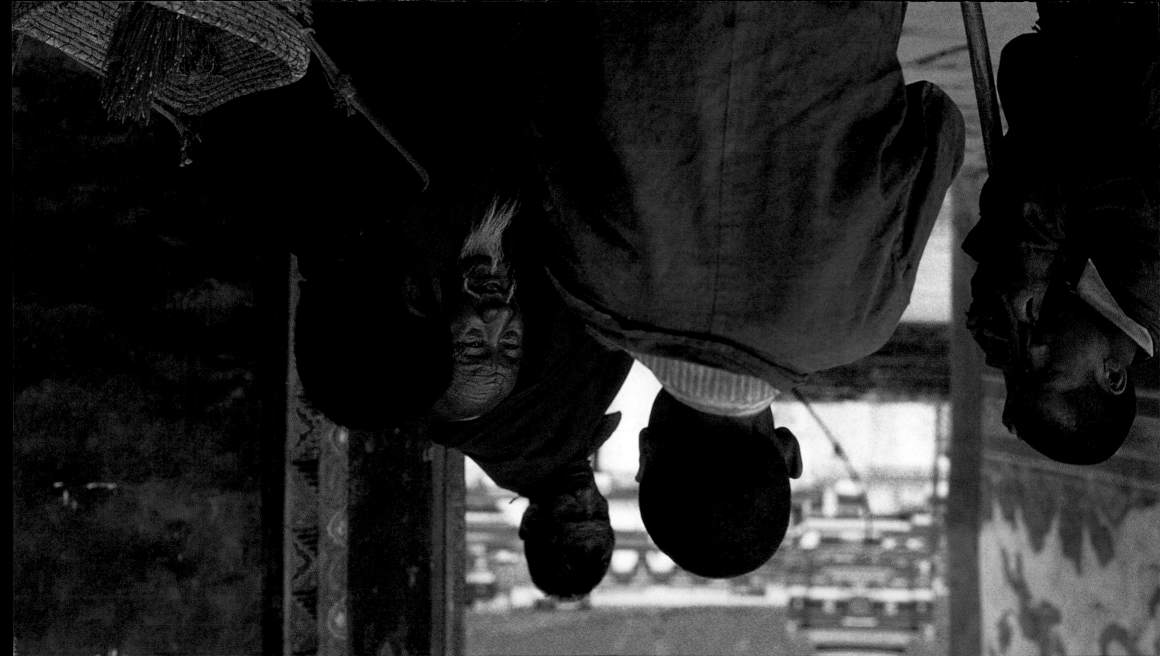

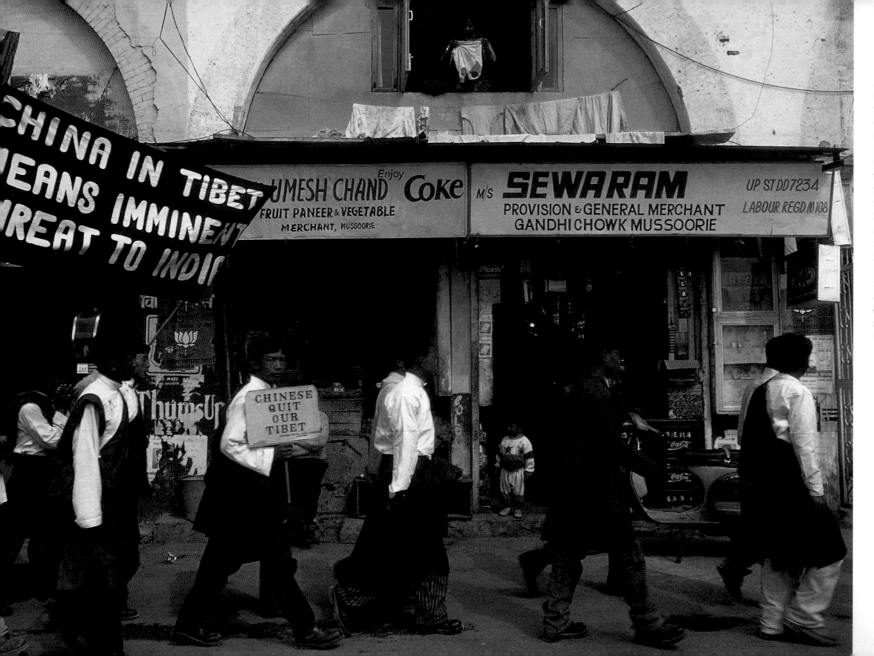

AN ELDER MONK (TOP) RECEIVES REPORTS OF THE DAY FROM HIS CHARGES, YOUNG STREET URCHINS WHO MAKE A LIVING SWEEPING THE STREETS OF SHIGATSE, TIBET. HIS MONASTERY, TASHILUNGPO, IS THE SEAT OF THE PANCHEN LAMA, WHO TRADITIONALLY HAS A FATHER/SON RELATIONSHIP WITH THE DALAI LAMA. PARADING IN THE STREETS OF DOWNTOWN MUSSOORIE (BOTTOM), STUDENTS OBSERVE THE ANNIVERSARY OF THE MARCH 10 UPRISING IN LHASA.

H. H. and Gandhi

BY TENZIN NORBU "A"
BORN IN TIBET IN 1981.
CAME TO TIBETAN HOMES
AT AGE ELEVEN.

His Holiness the Dalai Lama was very influenced by Mahatma Gandhi's philosophy of nonviolence as well as his application of *satyagraha* [nonviolent resistance] for political purposes. In this painting we see homage being offered both to the spirit of Gandhi and to the Dalai Lama's contemporary determination for a peaceful solution to the Tibet issue.

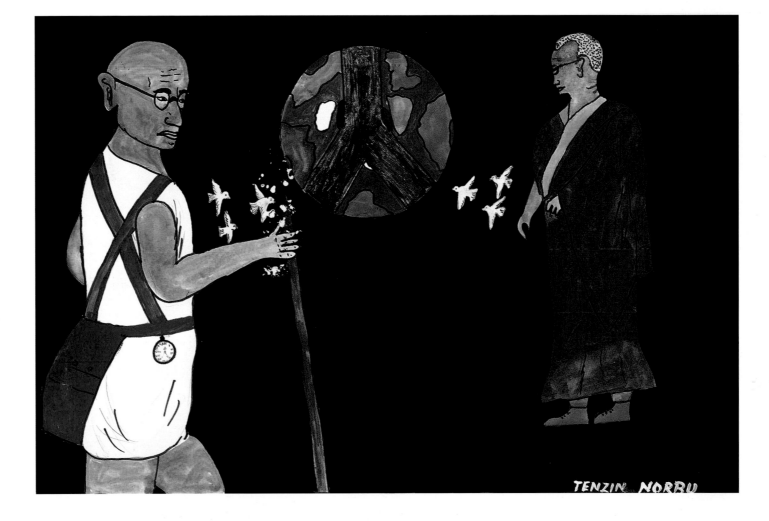

above
TENZIN NORBU "A."

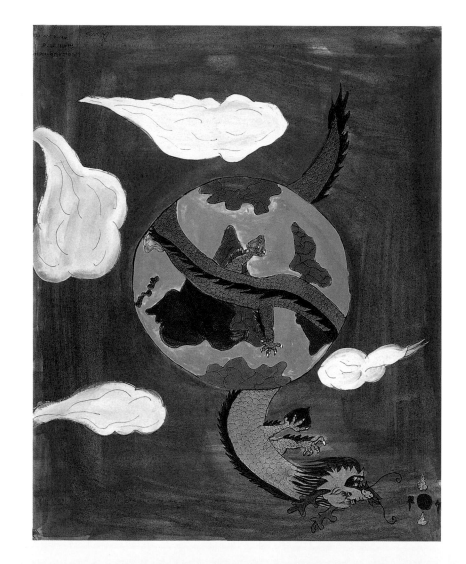

BY NGAWANG LOBSANG

Untitled

BY KARMA SOPA
BORN IN NEPAL IN 1980.
CAME TO TIBETAN HOMES
AT AGE FIVE.

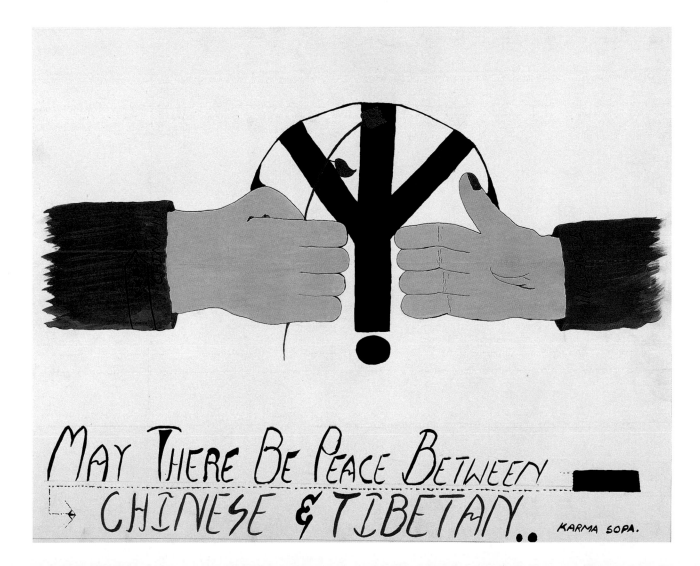

117

Nobel Peace Prize

BY DECHEN DORJEE
BORN IN INDIA IN 1982.

"I was at home, and we were all studying when we heard the news on the radio. I felt very happy and excited. It's something so special for His Holiness. After receiving the Nobel Peace Prize, His Holiness and Tibet were much more popular in the United States, I mean the world. Some foreigners did not actually know what Tibet means. So I painted these three flags of Tibet. One is meant for the temple. One is the peace flag."

Statue of Liberty

BY TENZIN JIGME
BORN IN TIBET. CAME TO
TIBETAN HOMES IN 1992.

This ironic painting cleverly combines a number of interrelated themes pertaining to Tibet: the idea of freedom as signified by the Statue of Liberty image, the role of women in the Tibetan freedom movement, and the colors of the Tibetan flag as a backdrop symbol for Tibetan independence and nationhood. The figure is dressed in the ceremonial *chuba*. She holds a prayer wheel overhead and Tibetan Scriptures representing the Buddhist teachings.

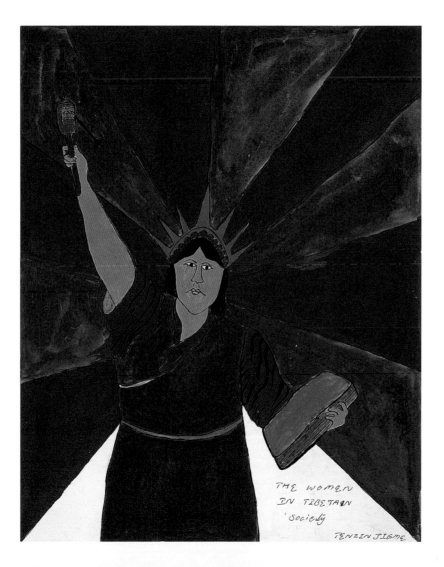

119

Deng Xiao Peng—Chinese Suppression

BY TENZIN NAMGYAL
BORN IN TIBETIN 1981.
CAME TO TIBETAN HOMES AT AGE SEVEN.

Where were you born?

Gyantse, Tibet.

How old are you?

Fourteen.

How old were you when you left?

Five.

Do you remember when you came here?

Not much.

This painting is very different from the other ones you did. What's that underneath the table?

Tibet.

Tibet . . . and who's this? It's like the world looking on . . .

Yes.

What is this man doing?

He's been locked in.

What did you have in mind when you drew this?

Telling the people to help us. Not to just be there watching but to help us.

Imagining Home, Imaging Exile

CHILDREN'S PAINTINGS FROM

THE TIBETAN HOMES FOUNDATION, MUSSOORIE

By Clare Harris

MOST OF US HAVE A CHILD'S PAINTING IN OUR HOMES, attached to the refrigerator with magnets or pinned to a notice board with other family memorabilia. We may even retain examples of our own juvenilia—those first attempts to draw home with lollipop trees and matchstick figures that have been proudly stored for posterity by our relations. These images remind us of the early stages of the evolution of consciousness and signify a state of innocence before our thoughts were tutored in the ways of the adult world. As we grow older we learn to understand our surroundings through images (among other things) and enter the

increasingly pervasive world of ocularity in the guise of global media, computer imagery, exhibitions, and publications. I distinctly remember my introduction as a child of six to the tutored viewing and representing that are taken for granted in the West. I was taught how to draw a box so that it appeared to be three-dimensional and in that moment was initiated into the post-Renaissance way of conscious-seeing. As the art historian Ernst H. Gombrich explained in *Art and Illusion*,[1] I had been introduced to a culture-specific system demarcated by perspectival grids and modeled in the shades of Renaissance *chiaroscuro*. It is therefore almost with regret and nostalgia that I experience the simplicity of a drawing by my three-year-old niece in which a heart is surrounded by multicolored irradiating lines as though the heart was beating out a pattern of love to be received by the viewer. For adults, such drawings become emblems of purity, innocence, and reminders of the sheer childhood pleasure of the use of paint and form. We take heart (in the case of my niece's image, almost literally) from the liberated, untutored child's-eye view.

How are we to view the paintings of Tibetan refugee children when they do not reflect such uncomplicated emotions and when they do not emerge from naive ways of seeing and depicting? The images produced by children at the Tibetan Homes Foundation in Mussoorie, India, present a range of ideas and emotions that derives from a very specific experience, recording the dark days of Tibet's recent history. Paintings by children who have grown up with the knowledge of violence, colonization, death, and exile will inevitably reflect the troubled times of a youth that has been disrupted. For these children the condition of innocence has been abruptly curtailed, and yet included here are many images that conjure up the hope and resilience of the Tibetan diasporic community and tell tales of childhood enthusiasms that are universal.

In 1984 I spent six months living and working in the community from which these pictures came—"Happy Valley" in the Indian state of Uttar Pradesh. During the days I worked as a volunteer English teacher in the Tibetan Homes Foundation school and in the evenings I helped adults with English translation and took part in social gatherings where I first began to learn about

Tibetan culture, history, and politics. Many of the paintings reproduced here are extraordinarily accurate portrayals of the life lived in Happy Valley, and seeing them has revived my memories of a place that did, in fact, live up to its name. Despite the devastating events in Tibet and the harsh conditions experienced by many Tibetans as they struggled to survive the first decades of exile in India (working on road-building projects and setting up "home" in sometimes difficult terrain donated by the Indian government), the atmosphere in Happy Valley was positive, a sense sustained by communal gatherings in which the values of the land vacated (Tibet) were re-created. As the place where the Dalai Lama had first been given a roof over his head in India (by the Birla family), Mussoorie was later designated by him to become the site of the Homes Foundation where the needs of orphaned and semiorphaned children could be met. Mary (Rinchen Dolma) Taring,[2] wife of the ex-*kashag* (Tibetan government) member Jigme Taring, was charged with the task of setting up both homes and a school for the children of exile. The Dalai Lama placed a high priority on the education of this first generation of children who would grow up in an alien host nation and who would be without access to the traditions of Tibet. Hence, the Homes Foundation would provide for their physical and emotional needs while also giving them a sense of their Tibetan identity and heritage.

Part of that project included the construction of a *gonpa* (monastery) on the edge of the Mussoorie settlement, which was to be run by a small group of Gelukpa monks. As in all the exile communities, the practice of Tibetan Buddhism in Mussoorie was seen as a vital way in which Tibetans could gain spiritual sustenance and be united. Submerging regional and sectarian affiliations, the imagined community or neonation of exiled Tibetans has gained solidarity through leadership from the Dalai Lama and a government-in-exile in Dharamsala and through the practice of Tibetan Buddhism. Thus, Tibetan cultural identity has been fused with a religious definition of what it is to be Tibetan and, hence, monks and preeminently the Dalai Lama embody ideas about Tibet's past prior to 1959 (the year of the Dalai Lama's departure into exile). In the early years in exile the task of reinventing Tibetan traditions fell to the older generation who had lived and been acculturated before the Chinese takeover of Tibet.

Their knowledge gave them a special status in the production of "authentic" Tibetanness. But it was not only monks and religious teachers who were part of what I have called the "precious," or *rinpoche*, generation (though *rinpoche* is usually used to refer to the precious teachers of Buddhism). The monastery in Mussoorie was designed to house precious monks, but it was designed by a layman of the same generation, Jamyang Losal of Amdo. Though constructed from modern Indian building materials, such as concrete and steel (rather than the stone, wood, and stamped mud used for monasteries in Tibet), it was "dressed" in Tibetan style with paintings by Losal based on his memories of such places in his homeland. Losal also produced a book in which the iconometric and iconographic specifications for religious images were laid down because, as he says, "during the course of my service, I realised the importance of preserving Tibet's unique painting for which I felt there was need of producing a scientific work."[3]

For Losal and others of the precious generation, the "unique" images of Tibet had to be conserved and would make such buildings as the Mussoorie *gonpa* effective as religious spaces. But they also played a part in the broader cultural exercise in which Tibet could be imagined by those of a younger generation who had never known or were too young to remember the homeland from which their parents came. It is important to identify this imagining of the past and imaging of the Tibet that has been absented, as they play a crucial role in Tibetan self/communal definition in exile and have impacted on the consciousness of the young. The production of traditional-style Tibetan paintings has been part of the process through which Tibetans counteract the "organised forgetting"[4] instituted by the Chinese (particularly during the Cultural Revolutionary period, 1966–76). In Chinese-controlled Tibet many of the monasteries and images that Losal remembered were demolished or removed to be replaced by buildings of the Chinese state with imagery reflecting Maoist ideology. Religious and cultural markers of pre-1959 Tibet are now, therefore, few and far between, thus the emphasis in exile on remembering through reconstruction.

However, though Jamyang Losal taught *thangka* painting (traditional scroll-type painting) to a small group of young Tibetan men, most of the children I encountered in Mussoorie in 1984 rarely had the opportunity to draw or paint, as resources for such a thing were limited.[5] The Homes Foundation school rightly focused on providing a practical education for survival that would enable the pupils to live and work in the host country of India, teaching the staples of Indian schools such as mathematics, history, geography, and English. Though the children also had classes in Tibetan language and history, the majority of their lessons were based on textbooks published by the Indian government. Hence, English was acquired through stories based on Hindu mythology with characters called Sita and Rama who lived in a world of elephants and tigers and subtropical jungle. There were no Tenzins or Yeshis, no yaks or snow leopards, and no prints on the classroom walls to evoke the landscape of Tibet. More recently, though, a number of Tibetan exile schools have begun to produce culture-specific educational material. At the refugee school in Choglamsar, Ladakh, such a project has been under way since the late 1980s where children are also taught by a *thangka* painter to draw the flora and fauna native to Tibet. The paintings here have been created with a similar intention in mind: to provide a creative outlet for Tibetan children and to allow them to depict themselves, their community, and their heritage.

In the West there is a well-established system for assisting a child's intellectual development through making objects and images. Most children will be encouraged to dabble with paint and gradually to learn how to depict the world around them. Some intelligence tests are even based on the analysis of children's drawings, with the visual "evidence" of details such as the correct number of fingers on a hand taken as a sign of knowledge. I certainly found that observation and learning could be usefully combined when one of the Mussoorie mothers asked me to teach her preschool daughter English. As neither Dechen nor I knew much of one another's language at this point, we improvised in informal classes at her home by pointing to things around us, naming them (in Tibetan and English), and recording the object in a picture. By drawing and naming in a secure environment we established a

basic vocabulary for communication. When I was asked to provide spoken English classes for newly arrived adult refugees, I used a similar system to overcome the reticence of my students and asked them to depict their surroundings. The paintings produced at THF are documents of naming and knowing as the children itemize the environment of exile. Much of what they record comes from inquisitiveness as they touch the things around them and learn their verbal and visual signs. But their pictures also illustrate attempts to touch the past and feel the future. Such images help Tibetan refugee children to assimilate to their host environment and to dream of things not available in reality. Sybil Milton suggests that images produced by children living under threat and with the memories of tragedy fresh in their minds can be part of a therapeutic process, a means of transmission of cultural heritage, and may provide "spiritual resistance" to some of the horrors of their situation.[6] These three themes come to bear on the paintings made by the children of the Tibetan Homes Foundation as they tell their own stories and those of their community.

The bookplates begin with children's memories of the passage to India in which thousands of Tibetans followed the Dalai Lama into exile in or after 1959. Ngawang Youden (see page 21) records the Dalai Lama's flight from Tibet through snowy mountain passes. The Dalai Lama and two members of his entourage are shown riding on yaks and evading Chinese soldiers who appear to be stuck in the lower passes on horseback. As the Dalai Lama makes his pathway toward the welcoming and auspicious rainbow of the freedom of India, Youden presents the Tibetan beast of burden, the yak, as the appropriate and superior mode of transport for high-altitude conditions. (The Dalai Lama actually made his journey on horseback.) Youden suggests that the Chinese have failed to comprehend the culture and environment they are dealing with. The Dalai Lama's success at escaping Chinese clutches is perhaps the most important event in recent Tibetan history and is commemorated by exiles in the March 10 gatherings that take place throughout the Tibetan diaspora. On this date in 1959, Tibetans gathered at the Norbulingka (the Dalai Lama's summer palace) to protest the increasingly threatening behavior of the Chinese, which they suspected would lead

to the capture of the Dalai Lama. The protests led to violence and deaths, and the event has since been labeled as an "uprising." But the Dalai Lama escaped, and as we, and hundreds of thousands of Tibetans who followed his path, know, the rest is history. For exiled Tibetans the hazards of the Dalai Lama's journey have become a leitmotif symbolizing the communal experience of a rite of passage. The fact that his exodus is recorded on film and shown in refugee communities throughout the world may have supplemented Youden's ability to depict and empathize with his story. The embodiment of the exile story in a single individual is one device through which refugee Tibetans are utilizing something along the lines of K. A. Appiah's notion of "scripted identity." He discusses the relationship between individual and group identities:

> Collective identities, in short, provide what we might call scripts: narratives that people can use in shaping their life plans and in telling their life stories. The story—my story—should cohere in the way appropriate by the standards made available in my culture to a person of my identity. In telling that story, how I fit into the wider story of various collectivities, is for most of us, important.[7]

Among diasporic, colonized, and marginalized peoples there is perhaps an even higher premium placed on the construction of these collective "scripts" than in other communities by virtue of the fact that the experience of "otherness" is a constantly reiterated experience when confronting a host culture and the memory of the past. For these groups one individual is seen to enact the communal story while simultaneously entering into the dialogic production of the "script," as is famously the case of Nelson Mandela in South Africa or Mahatma Gandhi in India. The Dalai Lama performs this role for Tibetans, and as the children's paintings demonstrate, the script of recent Tibetan history is one into which they can insert their own stories. Hence, images of loss and longing in which the children touch upon harrowing events of the past, such as *Remembrance of My Friend* (see page 25), *The Last Good-Bye* (see page 41), and *My Sorrow* (see page 31) suggest that the act of depicting may well provide some kind of solace. Tsetan Chompel's *Remembrance of My Friend* recounts a painful occasion but is a surprisingly cheery image, perhaps because he is not alone in retaining such memories.

Some of these images also illustrate a quiet heroism on the part of the young as they swam to freedom or crossed precarious bridges, as in Thakchoe's *Escaping from Tibet* (see page 27). We are reminded that the very young as well as the old and infirm somehow survived the arduous trip to Nepal or India. Tenzin Norbu's *Hiding* (see page 26) shows himself hiding in the trees as gleeful Chinese soldiers march through a devastated forest in hot pursuit of straying Tibetans. Norbu and his brother, dressed in a *chuba* (a Tibetan coat/dress), make the hand gesture of peace as they quake behind trees finding sustenance at a moment of crisis by enacting the values of Tibetan Buddhism and emulating their leader, the Dalai Lama. The exiles' script records that the Chinese both deforested the land of Tibet and showed little regard for its human and animal inhabitants, so Tenzin Norbu includes a tiny white rabbit cowering next to him. The sacrilegious behavior of the People's Liberation Army is reiterated in another of his paintings in which a soldier carries the corpse of a yak on his shoulders (see page 108). For a Tibetan Buddhist, the taking of the life of a sentient being (including yaks) is an inauspicious act (and butchers who carried out the task in pre-1959 Tibet were accorded low status as a result), but for Norbu the dead yak is doubly symbolic of the murderous intent of the People's Liberation Army toward all things Tibetan. In contrast, Tsering Ngodup's fine painting shows a *Mother and Child* (see page 91) cradling a fledgling bird and embracing Buddhist values. When I visited Mary Taring, the "mother" of the Homes Foundation, at her home in 1987, she held a small plastic bag with two or three flies buzzing around inside. When I asked why, she said that the insects had been bothering her but she would not kill them, preferring to temporarily trap and then release them upon my departure. Ngodup's clear and elegant evocation of the Tibetan ethos of respect for all sentient things reflects values that have been instilled in children at the Tibetan Homes Foundation.

In some respects, the paintings of Tibetan children's lives in exile are similar to those of children all over the world as they re-create the details of their daily existence. Tenzin Lobsang's painting of THF (see page 48) is wonderfully accurate with the multistory school building in the foreground and children at play or helping to unload goods from the service vehicles that bring

supplies for the homes in which they live. One of the notable things about Happy Valley is the way in which all ages are involved in sustaining the community. Children collect water or vegetables as older people work as construction laborers, teachers, administrators, and so on. Lobsang captures the landscape of the foothills of the Himalayas with tall trees and swooping birds. This environment provides some comfort for those refugees in the north of India as it is not so dissimilar from the Tibet they left behind. As I recall, open-air assemblies at the Homes Foundation school were often overseen by soaring eagles or chattering monkeys—much to the children's delight as they sang the Indian and Tibetan national anthems. Rinchen Phuntsok's portrayal of two of the homes in which orphaned children live (see page 53) also reminds me of the way in which, with limited means, the foster parents in Happy Valley tried to make life as "homey" as possible. Phuntsok has illustrated the cooking oil tins filled with flowering plants on window ledges and traditional Tibetan hangings of multicolored cloth placed over doorways with which house "parents" decorate the homes. Happy Valley is filled with such small markers of Tibetan life-styles.

But "Tibetanness" is also writ large onto the Indian landscape, as Lobsang Sangay's *Sangsol at THF* (see page 65) shows us. Beginning at the bottom right with the monastery (designed by Jamyang Losal), the artist leads the eye up the picture plane following the path of a ritually sanctified route. The path leads from monastery to *stupa* and along a prayer flag–lined meander to the top of the hill where auspicious and purifying juniper smoke billows skyward. In Happy Valley this area becomes especially important during religious holidays such as Losar (New Year), when the entire community follows what is in essence a kind of pilgrimage route, but it is also used on a daily basis by both old and young to perform the meritorious act of circumambulation. In pre-1959 Tibet, making the journey to sacred mountains such as Kailash and carrying out full-length prostrations around them were acts that most Tibetans hoped to complete at least once in their lives. The sanctity of high places, such as Kailash or the Dalai Hill in Mussoorie, reflects Tibetan attitudes toward the land, architecture, and the body, with all that is most sacred placed at the top. In domestic architecture, for example, the family shrine room is ideally placed at the top of the house, with

human living quarters on the top floor and animals at the bottom. (This arrangement has been re-created in the Happy Valley homes, where kitchens and living quarters are, where possible, on the first floor.) This pattern is also seen in operation in the peaks and passes of the natural environment where the spirits (called *lha*) are thought to reside and which must be placated with offerings and prayers. The hill at Mussoorie also has specifically Buddhist connotations as a place where the community reenacts the actions of the first Tibetan Buddhist king, Songsten Gampo, who walked to a hill in Lhasa to think and pray. That hill was later (in the seventeenth century) encased by the most famous building in Tibet, the Potala Palace, a building that retains great significance for exiled Tibetans as the former home of the Dalai Lamas. Lobsang Sangay's painting can be compared with that of Phuntsok Tsering's (see page 85), which also depicts the practice of *sangsol* but in this case as he remembers it being performed in Tibet. When interviewed about his image, Phuntsok could describe how he and his family took part in *sangsol*, reciting the word "*so*" three times and then throwing barley in the air. But he admits: "I don't know [what it means], but I know that it is a prayer to live longer and to keep bad things away." In fact, his description is basically correct. Both in Tibet and in exile, *sangsol* ensures that the environment is purified and merit is accrued by the participants, which may lead to spiritual, if not physical, longevity.

However, Tsering's uncertainty about Tibetan cultural practices reiterates a theme mentioned earlier. The Dalai Lama and other leaders of the exile community placed a high priority on ensuring that memories of pre-1959 Tibetan life should not be forgotten and that children should be tutored in many aspects of their history and culture. Tenzin Norbu's painting (see page 49) of a lesson in Tibetan language, with his teacher dressed in a *chuba*, illustrates one of the formal ways in which this objective could be achieved, but the children also choose to represent more relaxed pursuits in which they define themselves as Tibetans pursuing Tibetan activities, as is the case in *I Am Playing Carrom Board* by Tenzin Dhonten (see page 59). The picture shows a favorite Tibetan pastime, playing *carrom*, in which disks are shot into four goals at the corners of a wooden board. Thakchoe's *Picnic* (see

page 102), based on memories of Tibet, includes another favorite game played by Tibetans, *mah-jongg*, and a group of men engaged in a tug-of-war. As Hugh Richardson (the British representative to Tibet in the early twentieth century) records, important days in the religious and secular calendar were marked in pre-1959 Lhasa with all sorts of elaborate games that tested the endurance of their participants.[8] At New Year, the particularly hazardous "sky dancing rope game" was watched by thousands as a man slid "like a bird" headfirst from the top of a wooden pole on a taut rope. Given the unpleasant memories of their departure from Tibet, it is encouraging to find that the Homes Foundation children also remember some of the entertaining activities of the past as well as learning from the exiles at work and at play.

Much of the effort involved in reconstructing Tibet in exile has naturally been directed toward daily subsistence and creating an institutional infrastructure that supports and unifies Tibetans. But many of the activities that make exilic life bearable are more personal and even pleasurable. Weddings, for example, are two- to three-day-long events at which *carrom* boards are very much in evidence and the nuptials are celebrated to the sound of *mah-jongg* bricks clattering. Dances of the homeland are performed into the small hours, and children are allowed to stay up late to listen to their elders singing their memories of Tibet. These communal occasions provide confirmation of the continuation of tradition and like the *sangsol* ceremony "map" the space of exile with ideas based on the imagined geography and culture of Tibet. Paul Connerton[9] tells us that collective memory is more readily aroused in a secure environment in which the presence of familiar objects and activities triggers the capacity to rediscover the past in the present. A calm social framework with appropriate imagery of the past can help to support a sense of timelessness and stability. Hence, Tenzin Norbu's picture of a Losar meal (see page 89) and Dorjee Gyaltsen's *Losar Altar* (see page 87) could be based on memories of Tibet but are equally likely to have been drawn from refugee life in Mussoorie, where the Homes Foundation has made it its business to provide children with as many of those objects that trigger the past as possible. This project includes everything from clothing such as *chuba*—made from Indian cotton in the Homes Foundation tailoring department—

to foods such as *momo* (a kind of dumpling) and *gyathuk* (a noodle dish), made by Homes Foundation housemothers on special occasions. At Happy Valley, the director of the foundation also insisted that each home be provided with a plain depiction of the Buddha (rather like the one on the wall in Gyaltsen's *Losar Altar*), and most had a simple altar on which the daily offering of seven bowls of water, lit butter lamps, and incense was made.

The Homes Foundation environment provides a context in which children can be nurtured and tutored in the positive reconstruction of the Tibetan past brought alive in the present, but these children are also full of free-ranging imagination and aspirations for the future. Their dreams are sometimes expressed through influences from further afield and reflect their assimilation into the world of mass communication available to them in India. In 1984 the afterschool craze was for Michael Jackson–style disco dancing, which the children had seen on Indian television (on the one communal TV). Despite a technical hitch—they had no ghetto blasters and no cassettes—small Tibetan boys were not deterred and vied with one another to be the most impressive silent break dancer. Such major leaps of imagination could be said to characterize their situation as members of a diaspora meeting the challenge of the host and global communities. It is therefore no surprise that images in which they illustrate ideas about the future are projected toward the international community with messages inscribed in English, the language they learned as refugees in India but that gave them access to a larger audience.

Karma Sopa's *Tibet Bleeds* (see page 111) emphatically makes the point that Tibet needs to be saved from the crushing grip of the People's Republic of China. The map of Tibet is emblazoned with the words "Save Tibet," and three exclamation marks assert that this is an imperative that English-speaking countries must read and act upon. Sopa asks the international community to recognize the territory that was Tibet but is now designated, apparently without irony, as the "Tibetan Autonomous Region of China." In *Deng Xiao Peng/Chinese Suppression* (see page 120) by Tenzin Namgyal, an acute sense of the political position of Tibet is also clearly expressed. A figure representing Tibet cowers under the table of international diplomacy as Deng wags an admonish-

ing finger at him. The rest of the world looks on in the form of a globe-headed man who appears confused and impotent. He stands rigidly, as if his hands were tied, with nothing to put on the table to counteract Deng's document of "accusations against India." The sophistication of this image emerges from Namgyal's knowledge of the news, both in style (which is derived from Indian newspaper cartoons) and content. Tibetan exiles read about their homeland and China's control of it in Indian and Western newspapers wherein the Chinese are reported to protest against India's continuing protection of what they call the "Dalai clique." The 100,000-strong group of Tibetans living in India remains grateful for what it still hopes will only be a temporary home in India, a fact attested to by Tenzin Norbu's *H. H. and Gandhi* (see page 115). As "father" of the independent nation of India, M. K. Gandhi had overturned British colonial rule and helped to create the welcoming democratic country that Tibetans escaped to. He has also been seen as a role model for Tibetan refugees, and his biography was translated into Tibetan during the early years in exile for use in schools and homes.[10] The Dalai Lama sought to combine the teachings of Tibetan Buddhism with Mahatma Gandhi's practice of *ahimsa* (nonviolence) and *satyagraha* (holding on to truth), and so Norbu appropriately shows Gandhi and the Dalai Lama looking at a globe united by the peace symbol. As paragons of spiritual resistance to political realities, both men have inspired the exiles.

On the other hand, Tenzin Jigme's exilic Tibet is represented by an assertive female figure framed by the forms and colors of the Tibetan flag (see page 119). Jigme suggests that it is the women of Tibet who, prayer wheel and book in hand, will forge a path to freedom and independence in the future. As a child of the Homes Foundation, he has benefited from the strength and vision of such women in a very direct way. His painting should become the emblem for the Tibetan Women's Association, which has done so much to recognize the importance of women in the exilic situation, for they transmit the values of Tibetan culture on a daily basis. To paraphrase from the African-American experience, educated women can educate a nation. In borrowing the symbolism of the Statue of Liberty, Jigme envisages the new dawn of Tibet through the lens of American-style democracy and,

like the other children who produced "political" paintings, hopes that the West will not remain dumbly standing by as Tibetans valiantly and peacefully struggle on. His classmate Karma Sopa's optimism extends even further in hoping that there may even be "Peace between China and Tibet"(see page 117).

The children's paintings in this exhibition delineate the experiences that have molded their imaginations, charting a course from fears to hopes. In the first section of escape and the rite of passage we see therapeutic imagery through which the demons of the past are exorcised. In the second section, the paintings of Happy Valley perform the role of transmitters of cultural heritage as the children literally draw themselves into the embrace of Tibet reconstructed in exile. In the third set of images, spiritual resistance may provide a useful epithet, though the children are clearly conscious of a resistance that is actually political. From their temporary home in the north of India they dream of a wider world and a future that can be different. In 1984 I asked a class of teenagers from the Homes Foundation to write a story. The topic was: "The place I would most like to visit." When the essays were returned half were about Tibet and the rest about the United States. When we view these paintings, we might ask ourselves: Where should the dreams of these displaced children finally be actualized, and who can best help them to make their imagining of home more real?

NOTES

1. Gombrich, E. H. *Art and Illusion: A Study in the Psychology of Pictorial Representation* (Oxford: Phaidon Press, 1959).

2. In 1970 Mary (R. D.) Taring published her autobiography under the title *Daughter of Tibet* (New Delhi: Allied Publishers, Private Ltd.). John F. Avedon's *In Exile from the Land of Snows* (London: Michael Joseph, Ltd., 1986) gives further details of the Dalai Lama's experiences in Mussoorie and the creation of the Tibetan Homes Foundation.

3. Losal, J. *New Sun Self Learning Book on the Art of Tibetan Painting* (New Delhi, 1982), 8.

4. Connerton, Paul. *How Societies Remember* (Cambridge: Cambridge University Press, 1989).

5. In *Tibetan Refugees: Youth and the New Generation of Meaning* (New Brunswick: Rutgers University Press, 1984), M. Nowak also notes that during her fieldwork (1976–77) in Tibetan refugee communities in India, painting classes were a rarity in schools.

6. Milton, Sybil. *The Art of Jewish Children: Germany 1936–1941* (New York: Allied Books, 1989), 87.

7. Appiah, K. A. "Identity, Authenticity, Survival" in C. Taylor, ed., *Multiculturalism: Examining the Politics of Recognition* (Princeton, N.J.: Princeton University Press, 1994), 159.

8. Richardson, H. E. *Ceremonies of the Lhasa Year* (London: Serindia Publications, 1993).

9. Connerton, *How Societies Remember*.

10. *Jewel of Humanity Life of Mahatma Gandhi and Light of Truth His Teachings: Rendered in Tibetan Prose and Verse* was published in New Delhi in 1970 by Lobsang Lhalungpa, an important figure in the refugee education system. The text was published in Western format with illustrations by the artist known as "Master Topgay" of the Tibetan Craft Community, Palumpur, Himachal Pradesh. The frontispiece states that it was published to commemorate the birth of "Gandhiji," an event that Tibetans commemorated in 1969 with a pilgrimage to the site of his cremation at Rajghat in Delhi.

About the Authors

Sarah K. Lukas founded Friends of Tibetan Women's Association in 1990, an affiliate of Tibetan Women's Association in Dharamsala, to further TWA's efforts to improve the lives of Tibetans living in exile in India. As president of FOTWA, she has worked to establish sponsorship programs for Tibetan children, as well as for Tibetan elders and the infirm living throughout India. FOTWA supports Tibetan self-sufficiency through funding of day care and other programs. Lukas founded the painting club at Tibetan Homes Foundation, in Mussoorie, India, in hopes that through the language of art, Tibetan children will be able to express their feelings, to become more aware of their heritage, and to tell the story of Tibet.

Kitty Leaken's interest in Tibet began in 1992 when, as a staff photographer for the *Santa Fe New Mexican*, she met several Tibetans through the resettlement program in Santa Fe. Subsequent travels in India and Tibet introduced her to Sarah K. Lukas and Friends of Tibetan Women's Association. Under the auspices of FOTWA, Lukas and Leaken have made several extended trips to Tibetan settlements in India. Leaken's documentary photographs of Tibetan culture in exile are incorporated into the exhibit "At Home Away from Home: Tibetan Culture in Exile," sponsored by the Museum of International Folk Art in Santa Fe.

Clare Harris, Ph.D., is a lecturer in the anthropology of art at the University of East Anglia, Norwich, United Kingdom, where she teaches courses on the visual culture of India, the Himalayas, and Tibet. Since her first visit to India at the age of eighteen, when she worked at the Tibetan Homes Foundation school in Mussoorie, she has made frequent fieldwork trips to India, Nepal, and Tibet over the last thirteen years. Her doctoral thesis, "Depicted Identities: Images and Image-makers of Post-1959 Tibet," is due to be published in 1998.